Painting Portraits, Nudes & Clothed Figures

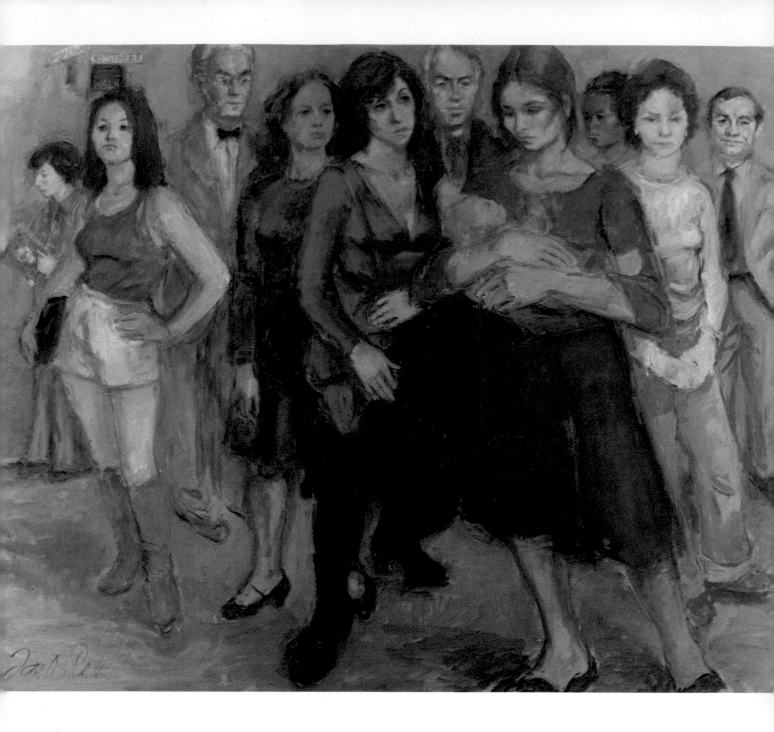

Painting Portraits, Nudes & Clothed Figures

By Jan DeRuth

Watson-Guptill Publications/New York

First published 1981 in New York by Watson-Guptill Publications,
a division of Billboard Publications, Inc.,
1515 Broadway, New York, N.Y. 10036

Library of Congress Cataloging in Publication Data
De Ruth, Jan, 1922–
 Painting portraits, nudes, and clothed figures.
 1. Portrait painting—Technique. 2. Nude in art.
3. Human figure in art. I. Title.
ND1302.D39 751.45'42 81-10349
ISBN 0-8230-3728-2 AACR2

Manufactured in Japan

First Printing, 1981

1 2 3 4 5 6 7 8 9/86 85 84 83 82 81

To my sister Ruth

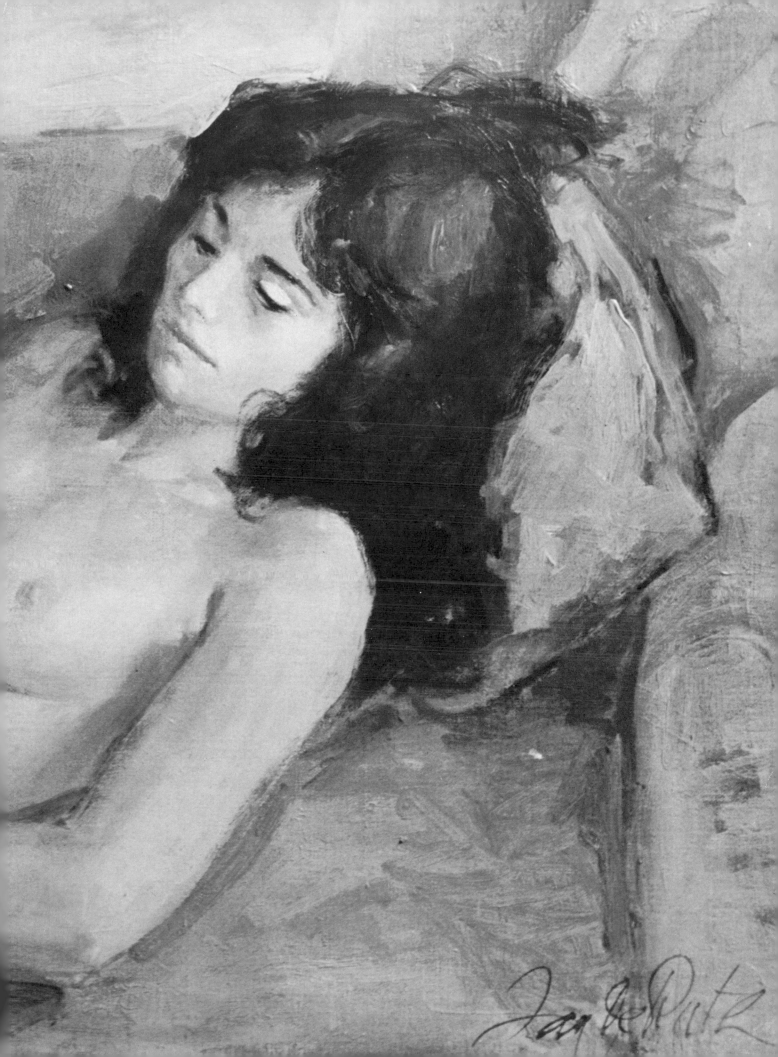

CURRENTS OF THE SPIRIT, 20" × 30"
(51 × 76 cm). Collection Mr. and Mrs. David B. Schwarz.
Courtesy Harbor Gallery, Cold Spring Harbor, N.Y.

Placing the figure on a diagonal across the rectangular canvas resulted in the pictorial seductiveness of this painting. I used oil pastels, overpainting the skin areas in light pinks, the hair in dark blues, the area of the couch in pinks of a somewhat stronger hue than the pink of the body, and the background in a light blue.

I then glazed the shadow or darker skin areas, using a sable brush, applying the glaze in such a way as to allow the oil pastel to show through. This was done by scraping some areas and leaving others opaque, thus creating a mix of textures to engage the eye of the beholder. I overpainted the areas upon which the figure is resting with various tones of Mars yellow with a touch of black and flake white. The background is in light hues of ultramarine, with a touch of cadmium red and raw umber to achieve various shades of light gray.

Note that almost all delineations of form stop short of the edge of the canvas or any rendered form, softening the impact on the eye and spirit and allowing the viewer to finish the painting in his or her own mind.

CONTENTS

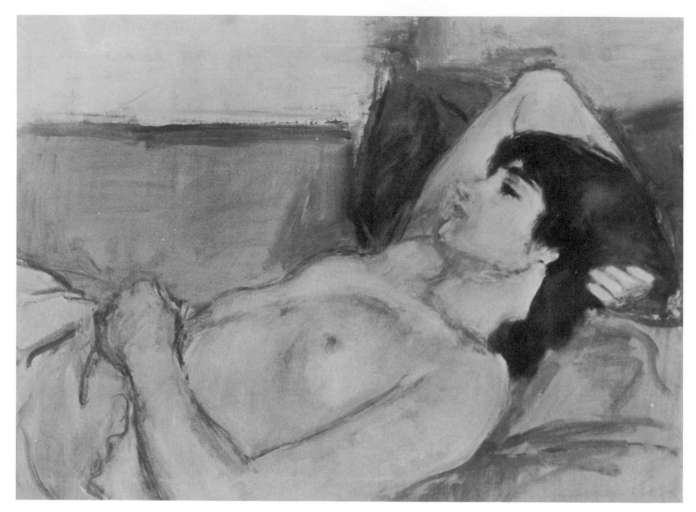

PERIPHERY OF DREAMS, 16″ × 22″
(40½ × 56 cm).

In this painting, triangles have been placed in opposition to
the round, soft shapes of the female form, thereby enhancing the
composition. The triangles are formed by the arms, which are
moving in opposite directions, the upper arm cutting through the
"triangle" of the pillow and into the horizontal background line,
thus uniting three areas.

How does one arrive at a well-balanced composition? First
you allow the model to move as freely as possible. This can be
done by sketching for an hour or two before the start of a
painting. Sooner or later you will find a pose that has the right
movement to fit your mood of the moment. The model's pose is
only the beginning. As the painting progresses, you adjust the
shapes surrounding the figure to fit within the square canvas,
either to be in contrast—the straight line at top of the
canvas—or in harmony—the corner of the pillow and the folds
floating from the hand resting on the belly.

ACKNOWLEDGMENTS

I wish to thank Fred Taubes, without whose teaching there would be no books by me. Without him I would not have met Jules Perel, who inspired this book; and Don Holden, who conceived and structured it. Don also introduced me to alkyds. These friendships mean much to me.

I would also like to thank Dorothy Spencer, whose common sense, strong head and hand guided this book; Kay Kitner Bogie, whose editorial skills and dedication were invaluable; Kelly Carroll, my great model, who brought so much to my paintings, turned the other cheek, and helped with the typing; Barbara Kassell, a friend in need and a great typist in an emergency; Dorothy Abelson, who introduced me to oil pastels; Janis Krisans, whose idea it was to add ordinary flake white to alkyd flake white—a most valuable contribution; and Wink Jaffe, in whose kitchen in Aspen many of the "recipes" in this book were devised.

The photographers were Ann Plimped'or Racz, Elisabeth Chase, William D. Grey, and Jose Hanania.

I wish especially to thank Brian Mercer who so beautifully designed this book from cover to cover.

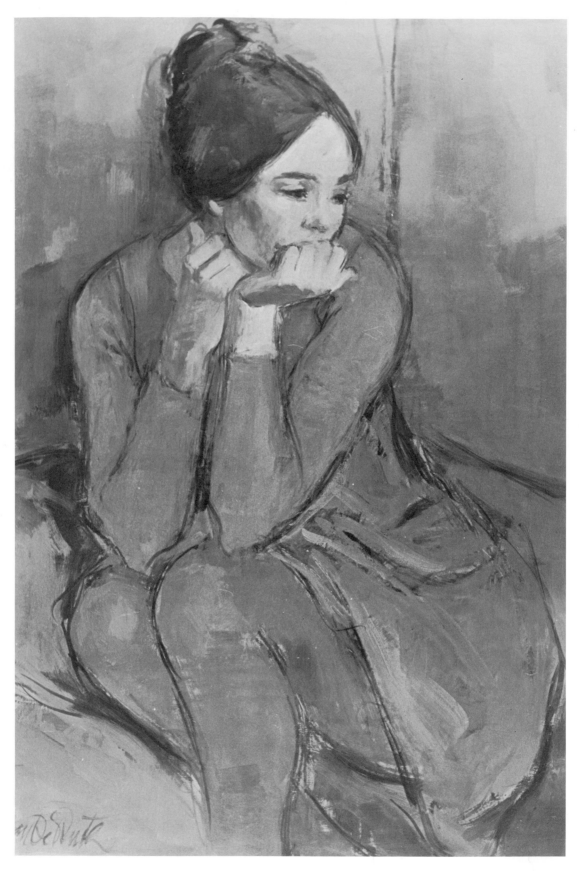

CORNER OF A ROOM, 34″ × 24″ (86½ × 61 cm).
Private Collection.

One of the safest procedures to achieve a good composition is to draw an imaginary vertical line through the middle of the canvas. Place the figure just slightly off center and the composition is begun. Composition should never be obvious.

Should the viewer be aware of "how good" the composition is, then the rest of the painting would be overpowered by the composition. In this painting the figure is turned in one direction while the head faces the opposite way. The drawing and painting harmonize with a feeling for the figure's motion rather than its anatomical realities.

PREFACE

An artist's painting style is as unique as his handwriting; it is a personal calligraphy, a product of each individual's perception of the world. Yet, often, many years are wasted in the pursuit of a "style" when in truth such a search is frequently nothing more than a hit-or-miss attempt to master one technique or another. Technical accomplishments should be acquired from the study of the methods of the great artists of the past.

We could not read or write unless we learned the letters of the alphabet. The same principle applies to painting: unless you have a complete knowledge of tools, materials, and their functions, you will find it most difficult to express your feelings, no matter how deep they may be. This does not mean that a good technician will become a great, or even a good, artist. But the confidence that you derive from mastery of technical skills will give you an enormous head start in your daily struggle to improve as an artist.

This book will help you acquire technical knowledge of the time-tested methods that artists have used successfully throughout the history of painting. In these pages you will discover the techniques that will assure the durability of your paintings and enable you to produce aesthetic results. You will see many details of paintings that illustrate the proper use of materials and tools and their application to the painting of figures, clothed or nude, and to portrait painting.

Among the twelve step-by-step demonstrations prepared for this book, you will find the basic methods for underpainting, glazing, and scumbling. You will also learn of new materials with which you can enhance the methods of the masters. One new technique is the use of oil pastels as underpainting, which allows the introduction of more color variety into an alla prima painting. Then there are the fast-drying alkyds, recently developed oil paints that allow a painting to be completed in days instead of weeks.

I hope that this book will expand your technical knowledge, increase your aesthetic abilities, and strengthen your belief in yourself as a painter.

Jan De Ruth

Part One:
Materials and Equipment

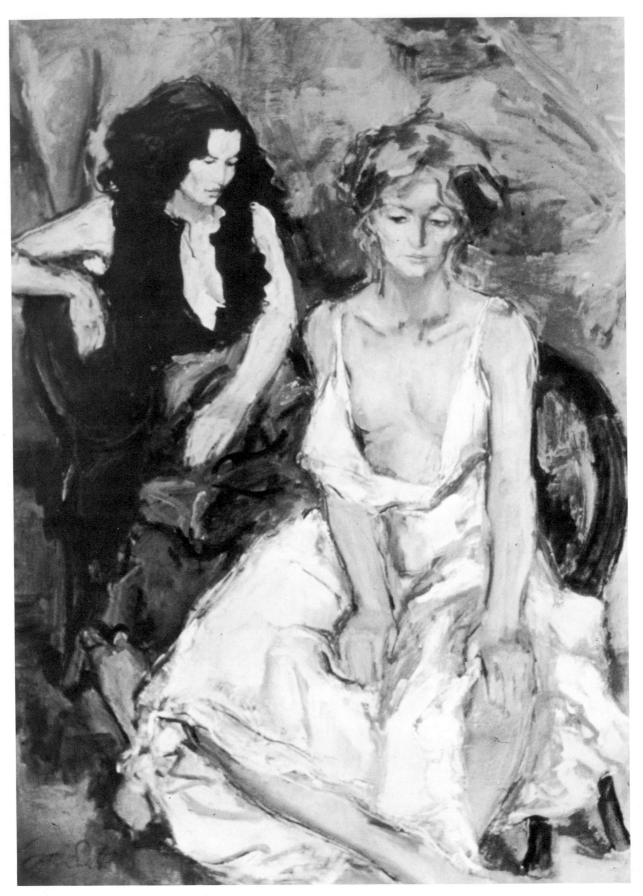

DRESSING ROOM, 40″ × 30″ (101½ × 76 cm).

In the following section on materials and tools you'll find several details from this painting, each of which shows how a particular tool is used. You'll also find *Dressing Room* in color on page 33. Look at the details to see how the smaller parts fit into the total composition, how through the use of different tools and materials one achieves a variety of textures, forms, and colors that together produce an exciting and harmonious paint surface.

THE PAINTER'S TOOLS

I firmly believe that the chances of producing a good painting are much better when hand, eye, mind, and soul blend into one, without being distracted by having to search for a brush, a knife, or a tube of paint. The mechanics of painting must be second nature to the artist. The feelings that produce good paintings are fragile at best and must be protected. The way to do that is to be in complete command of your studio; the tools of painting are but servants to your feelings.

I have organized everything I normally use to paint in a mobile painting cabinet, which I always keep within arm's reach. On top of it are three containers: one for large brushes, one for small brushes, and a third one for painting knives and scriptliners. The paint tubes are also on top, arranged by hue. The drawers contain all the other things that I would need in the course of the day: charcoal, oil pastels, extra tubes of paint, a small hammer, screwdrivers, pliers, silicoil jar, painting knives, scissors, sandpaper, cheesecloth, and paper towels. I use a wooden palette, the largest available.

It is essential to choose your drawing and painting tools with care and to understand the variety of their uses.

CHARCOAL

The first drawing utensil the art student usually encounters is the charcoal stick. It's the least satisfactory drawing tool for working on paper, but for drawing on canvas it's irreplaceable, especially if you're not yet skilled enough to draw with a brush.

EASEL

Your easel should be the largest and sturdiest you can afford. It should be easily adjustable to any height, allowing you to work on as large a canvas as possible. The easel should be mounted on small rollers for easy maneuvering around the studio.

PALETTE

Use a wooden palette. It acquires a lovely warm, mellow tone after a few days of use, and it responds very well to the brush or palette knife. I suggest that you buy a large one, either rectangular or kidney-shaped, at least 24 inches (61 cm) long. Smaller palettes have a crowded mixing area and become messy very quickly.

CANVAS

For smaller paintings, I use double-primed linen canvas, not too rough yet not too smooth. Since the price of linen is getting higher, however, don't hesitate to use cotton. For alla prima painting (see Demonstration 1, page 62) it's best to use the smoothest linen available and to add a light coat of priming color to eliminate as much of the grain as possible.

The weight of the canvas should increase with the size of the painting. The same principle applies to the stretchers. A canvas over 45 inches (114½ cm) in either dimension should be stretched on stretchers 1 inch (2½ cm) thick and 2½ inches (6½ cm) wide, with one to two crossbars. The ordinary commercial stretcher, sold in most art-supply stores, is fine for smaller pictures, but it cannot support a tightly stretched larger canvas. It will bend and buckle, lose its shape, and thus become troublesome during painting. You should always keep a good supply of stretched canvases of various sizes on hand so that you won't be caught short when a given subject demands a certain size or shape. For portraits, the availability of more than one canvas size is especially important.

STRETCHING THE CANVAS

For stretching canvases you need a tool like pliers called a "stretcher" and a heavy-duty staple gun. First, assemble a stretcher frame of the desired size. Use a T-square, or place the stretcher inside the frame of a door to make sure the stretcher is precisely square; otherwise the stretcher may not fit into the frame. Frames allow only about ¼ inch (6½ mm) tolerance. Connect the stretcher in each corner with a staple or two, making sure it keeps its proper shape.

Unroll the linen on the floor, place the stretcher on the canvas, and cut around it, leaving a 1½-inch (4-cm) border of canvas on all sides. Be sure that the size markings of the stretcher face you so that you won't have to measure later. Then staple the linen to the stretcher with two or three staples on each side. Never use too much force when stretching, but use even pulls, and staple from the middle to the corners.

Good stretchers have openings inside the corners for triangular wooden keys called wedges, which are inserted to restore tautness to the canvas when you paint. Don't force in these keys before you actually begin to paint. Be careful when hammering the wooden wedges into the corners; stay away from the canvas. Be gentle and tap the keys slowly into the stretcher holes. This will prevent cracking.

PREPARING THE CANVAS

The procedure described in the following paragraphs is simple and assures some degree of permanence. Naturally, it's more efficient to prepare more than one canvas at the same time.

The first step is to apply the glue sizing, which isolates the linen from the oil content in the primer and in later paint strata. I use rabbit-skin glue. First, bring about a quart of water to a boil, then turn off the flame. Add about five or six tablespoons of glue—in finely granulated form—but don't boil the glue, which decreases its adhesive quality. Apply this mixture with a sponge or with a house painter's brush about 4 inches (10 cm) wide. Be sure to cover the whole canvas, especially the edges, to prevent raveling. Don't place the canvas near a radiator or other heat source to rush the drying; let it dry at normal room temperature.

After the size has dried, the surface of the canvas will be slightly rough; use fine sandpaper to smooth it out. Then apply a second coat of sizing. You don't need to smooth the second coat with sandpaper.

PRIMING THE CANVAS

Flake white is ideal for priming. It's lean in consistency and dries fast. (See my comments on flake white on page 30.) Put the required amount of flake white on the center of the canvas and add enough mineral spirits, turpentine, or retouch varnish to produce the consistency of a well-mixed house paint. This will make it easier to move the paint. To spread it, use a priming knife with an inflexible blade. Spread the paint evenly all across the canvas. Smooth out any unevenness with the knife, moving lightly across the surface.

After a day or two, apply a second coat of flake white. Tone this coat with a touch of raw umber until you obtain the shade of very light coffee. With a knife, spread the paint evenly across the canvas, pressing it into the fibers but allowing the canvas tooth or grain to show through. In the final painting, the canvas tooth should remain an integral part of the surface wherever the grain of the weave can vary and enhance the effect.

A newly primed canvas should be left to dry completely. During humid periods this may take up to three weeks; in dry ones, no more than a week. I don't recommend adding fast-drying siccatives to priming colors.

BRUSHES

You should own a wide variety of brushes, at least two of each size. To become attached to a certain brush is hazardous, since the facility acquired with a limited set of tools may well turn into slickness. Change your brushes as often as possible, and find new uses for them. Painting is an adventure, not a routine.

PAINTING KNIVES

Painting knives should be well balanced, with a straight blade attached to a straight handle. Their flexibility varies with their function.

Painting knives with short blades and bent handles are quite useless. They're too flexible—because of the bent handle—hard to control, and very unwilling to let go of paint. They can't be used for blending, which is vital to a harmonious paint surface.

You will find a good set of knives under the trade name Taubes Painting Knives.

CLEANING YOUR PAINTING TOOLS

PALETTE. The mixing area in the center of the palette must be cleaned daily. If you allow paint mixtures to harden and accumulate on the palette, they will confuse later mixtures and distort color values. Tube color accumulated around the mixing area must be removed every few weeks. Scrape the palette with a knife, then wipe it with a soft rag dampened with a little medium.

BRUSHES. Only proper daily cleaning will keep your brushes in working order. First, wipe all the paint from each brush with a paper towel. Then wash the brushes with mild soap and lukewarm water, rubbing them against the palm of your hand to produce a heavy lather. Rinse once or twice and repeat. Remove as much of the moisture as possible with a soft paper towel and let the brushes dry completely.

Should you be a little less cautious or thrifty, get yourself a jar and a container of silicoil, a petroleum-based liquid. The jar contains a coil to which you add the silicoil. Pour in enough to cover the bristles or hairs of the brush. Move the brush lightly across the coil after soaking it for a few seconds, wipe the excess, and repeat while reshaping the brush. If you use your brushes daily, silicoil works fine. It can be reused; add some to the jar every now and then, but there is no need to change the contents entirely. Eventually, however, you should lift the coil, clean out the residue, and start anew. This method of cleaning brushes is never as good as soap and water, but it saves a lot of time.

MEDIUMS

A medium is the vehicle used to dilute paint. Mediums containing oil—linseed oil, sun-thickened oil, and stand oil—are called fat mediums. Mediums containing no oil—turpentine or retouch varnish—are fat-free or lean.

To be sure that a paint surface is permanent, so that the surface won't crack, you must paint "from lean to fat." This means that paint in the lower layers should contain a fatless medium. As you progress, add medium to the paint, in the final stages the paint should be quite fat. (The safest way, of course, is to use paint without any vehicle in the early stages.) Paint without any medium or with a fat-free medium dries faster than paint mixed with a fat medium. If you apply a fat paint first, it will probably still be wet when you add the next layer. As the lower surface dries, it expands, pressing against the

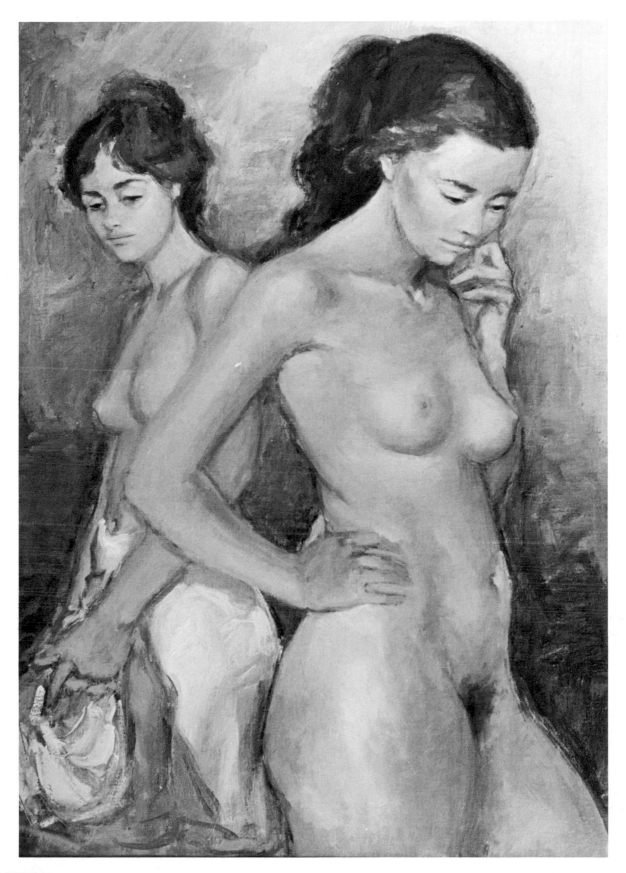

TANDEM, 36″ × 24″ (91½ × 61 cm).

Many paintings in this book show more than one figure. It would be impractical to have both models posing at the same time. In most of these paintings the models have never met. I start off with one figure, put the painting aside, and wait for the right model to come along, adding one or more figures. Quite often this may work in your mind but once the figure is actually painted, it may not fit at all. There is one remedy then. And that is to scrape the figure out of the wet painting, sandpaper the surface after it dries, then paint a new figure in place of the old one.

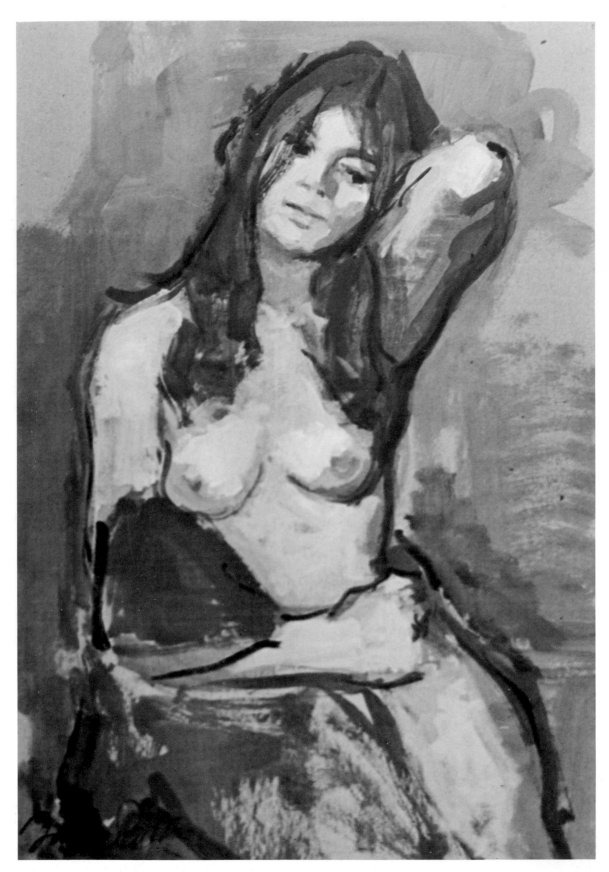

MORNING, 30″ × 20″ (76 × 51 cm). Private Collection.
I did this painting, or rather oil sketch, on a piece of gray cardboard which is highly absorbent and allows the paint to dry rapidly, forcing a certain spontaneity. Breaking the routine of working on canvas or a panel by introducing something as unorthodox as cardboard will add a great deal to your growth as a painter. Using cardboard brings about a certain carefree spirit which loosens your hand and spirit. This will also free you from technical precepts and allows room for discoveries. They may not be great discoveries, but I find that the changes that come about in my painting are not big ones, but minor ones that with time result in growth.

dry, brittle layer above, eventually cracking the surface.

Most manufacturers offer ready-mixed mediums that produce satisfactory results. If you wish to mix your own, however, the following combination is a good one:

1 part dammar varnish
1 part stand oil
1 part turpentine

Add a little turpentine now and then, since it evaporates.

VARNISHES

You should varnish only after a painting is safely dry. A light retouching varnish can be applied a few weeks after the painting has been completed.

Varnishing should always be done in dry weather. The painting should first be cleaned of any dust with a soft cloth. Apply the varnish with a soft cloth or soft hair brush, brushing evenly and in one direction; don't move the brush back and forth as you would a scrubbing mop.

There are two kinds of varnishes worth knowing about:

RETOUCHING VARNISH is a very light varnish that can be used as a vehicle in the early stages of a painting. You can also use it to revive dull, dried areas—to restore the brilliance of your colors—as you paint. When you've put aside a canvas for a while and return to find the surface thoroughly dry, retouching varnish can act as a binder for the next paint layer if you spread it thinly across the whole canvas. The varnish dries within minutes and remains slightly tacky for some time, providing a good surface for paint adhesion.

Retouch varnish in spray cans is a very important aspect of some of the demonstrations in this book. To use the can properly, hold it parallel to the canvas at a distance of about 8 to 10 inches (20½ to 25½ cm). Move the can along the canvas evenly while spraying *lightly*—you can always repeat the procedure if you find dry and dull spots. For a final varnish, it is still best to use a brush or a soft cloth.

RETOUCH VARNISH in spray cans is a terrific help when you're working with oil pastels, because varnish would be difficult to apply with a brush without "mixing" the colors and making a general mess. Since spray cans are available, let's use them. (See Demonstrations 7, 8, 11, and 12, pages 94, 99, 114, and 118.)

DAMMAR VARNISH is a light varnish that is applied as a protective coat to a finished painting.

ALKYDS

Alkyds are new pigments manufactured by Winsor & Newton that are extremely fast-drying. Alkyds dry within twenty-four hours to the touch and are then ready to be glazed, overpainted, or scumbled on. I have worked with alkyds for two years and they are terrific to have around:

Since you can mix all oil paints with alkyds, you can overpaint with either a second layer of alkyds or any other oil paint.

Their tint is much more brilliant than that of ordinary oil paints.

You can work them with any brush, sable or bristle, and any knife.

Alkyds dry evenly, without dull or shiny patches.

The possibility of yellowing has presumably been eliminated, though this quality will have to prove itself in time.

You can put on a final varnish one month after finishing the painting.

Since alkyds dry so quickly, they give the equivalent of a lean surface that has been drying for a week or more.

You can underpaint a portrait one day and continue painting the next day.

Since the alkyds are stiff, you can produce a kind of dry-brush effect which adds more variety to your textures.

There are drawbacks, however:

As for anything else that is new, you must get used to them.

The pigment is "short," stiff and difficult to manipulate when compared with ordinary oils.

The alkyds dry fast not only on the canvas but also on the palette, so squeeze only small amounts onto the palette until you get used to them. Otherwise, most of what you squeeze out will dry on the palette. After a day's painting, clean your brushes carefully. I use silicoil, but to be safe, you should wash them in soap and water.

I haven't found a way to keep my palette clean as with ordinary oils, so I use two different palettes, one for oils and one for alkyds. Alkyds accumulate much faster, even in the center of the palette. At the end of the day, instead of scraping, you can paint some tone of umber with a little white over the center and the next day start on this dry neutral tone.

The major drawback to alkyds is that some pigments tend to dry in the neck of the tube if you leave them for a few weeks. This can be partly avoided by wiping the exterior of the neck and the interior of the cap before replacing it. It's bothersome, but it's nothing compared to the advantages of these paints.

Winsor & Newton suggests the following thinners for alkyds: white spirits turpentine, Liquin, Wingel, Oleopasto. They are all based on alkyd resins.

There is one more thing that facilitates the use of alkyds enormously. I mix alkyd white with the white of a regular oil, about two parts regular pigment to one part alkyd. This slows down the drying of the color most used, makes the white much more pli-

able, and keeps it from drying or getting lumpy during use. (I learned this from Janis Krisans, a fellow artist who is an all-around good source of information.)

Winsor & Newton has recently produced alkyds with different drying times; I would suggest that you experiment to see which will be the most satisfactory to you.

To begin with, get yourself a limited palette of alkyds; don't deny yourself the results you can achieve with their use.

OIL PASTELS

An oil pastel is the same pigment found in the tube but in a much drier form. Because it's dry, it's a good underpainting medium. You'll find different qualities from different manufacturers, and you'll find out quickly which are inferior, too soft or too hard.

There are no color labels on oil pastels; when I refer to colors I use broad terms like "light blue" or names that correspond to the colors of oils in tubes.

Apply oil pastels roughly; don't bother about detail; use parallel lines; don't cross one color with another, which might produce a muddy shade. Keep them clear—that is their forte. They should become part of the finished surface. When you're using more than one color, be sure to wipe the sticks, because they do pick up residue from others. They don't mix well unless diluted by a medium such as turpentine, but you can spray them with a varnish, let the varnish dry, and add another layer as soon as possible, if you wish to use them by themselves. They make lovely pictures. But our purpose is to use them as underpainting.

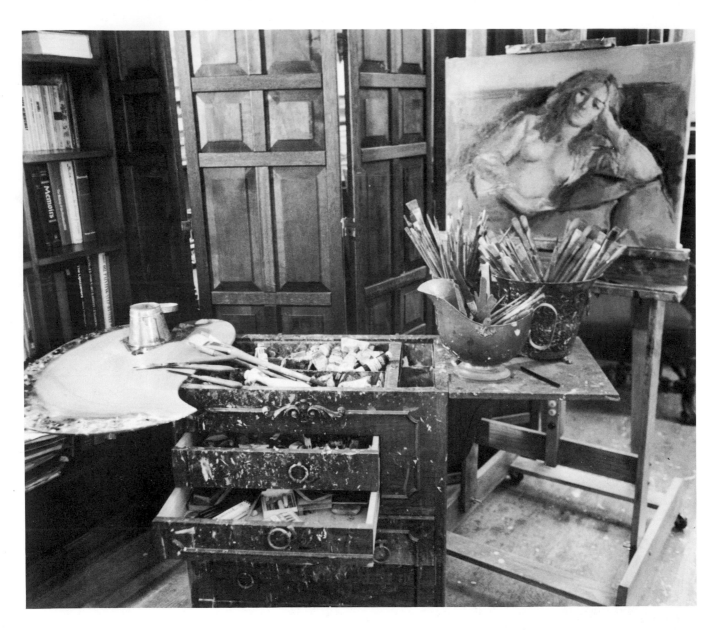

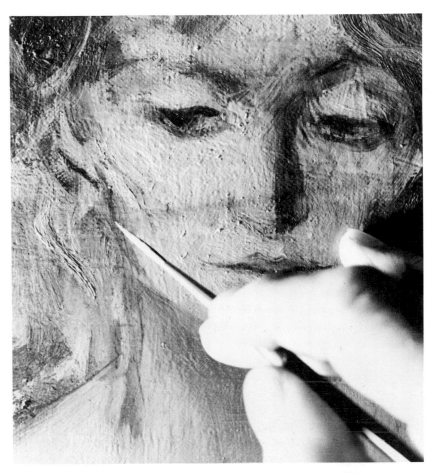

SCRIPTLINER.

I can't emphasize enough how useful this tool can be. A scriptliner is a short-handled sable brush; its hair is a little longer than that of a watercolor brush of similar shape. It is the perfect brush for refining an original drawing. You'll want to use a scriptliner again and again while your painting is in progress, either to reestablish the drawing or to define certain linear passages.

To use the scriptliner properly, fill it with diluted paint and draw with only the point of the brush touching the canvas. Don't press the brush against the canvas, or you will lose the drawing line. If you wish to achieve a broader stroke, just press slightly.

If you work with a stiff paint, you must add a great deal of medium when you use a scriptliner; you may be able to use the scriptliner without any medium. The most useful scriptliners are numbers 2, 3, and 4.

ROUND SABLE BRUSHES.

Round sable brushes should be used to rough in a figure in the initial stage of a painting. Turpentine combined with raw umber is best for such sketching. These brushes hold medium (turpentine) and pigment easily. Allow only the point of the brush to touch the canvas to get more mileage from the medium and the paint. The round sable brush is also the best tool for establishing folds and other linear passages, except during the final stages of a painting.

FLAT SABLE BRUSHES—LARGE AND SMALL. Flat sable brushes should be used with paint that has been diluted with medium. They leave a minimum of brush marks on the canvas. You can load them with pigment or use the pigment sparingly. They are the proper brushes for glazing. They don't lend themselves to applying paint over large areas. Whether large or small, sable brushes are good for details because they are easier to control than bristle brushes. They're also useful for painting skin tones, particularly where you don't want too much pigment, such as in the early stages of overpainting, glazing, and light or medium scumbling.

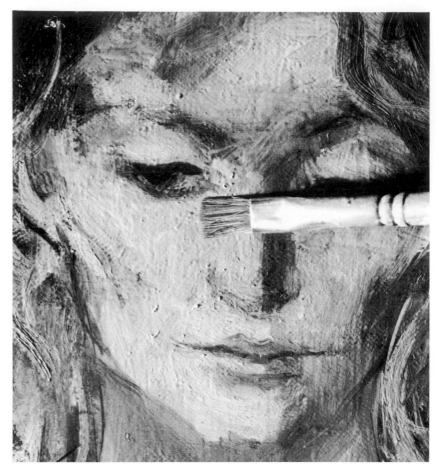

Larger sable brushes are ideal for glazing shadow areas on garments that will eventually be partially or fully covered by scumbles. Almost all background glazes should be applied with large sable brushes. Very large flat sable brushes are perfect for blending.

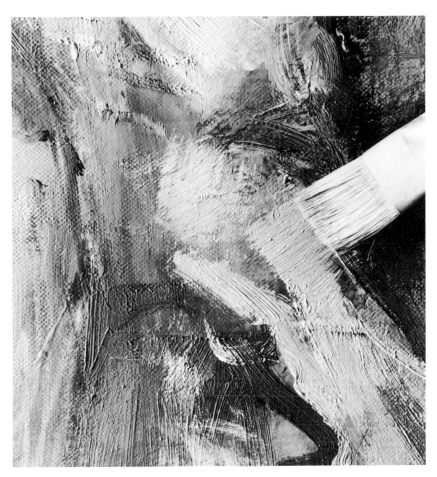

SHORT BRISTLE BRUSHES. When thick or short paint is to be applied, the short bristle brush is the best tool. This brush doesn't improve with age or produce any special effects. If it isn't used correctly, it will scrape paint off rather than deposit it on the canvas. Short bristle brushes are good for painting into glazed areas of hair, and they are good scumble brushes for areas that you wish to cover with a heavy layer of paint that will eventually be blended with a knife. In areas where brush strokes should remain visible, short bristle brushes add textural variety. They are good for applying vigorous strokes. I prefer longer bristle brushes because they are more pliable.

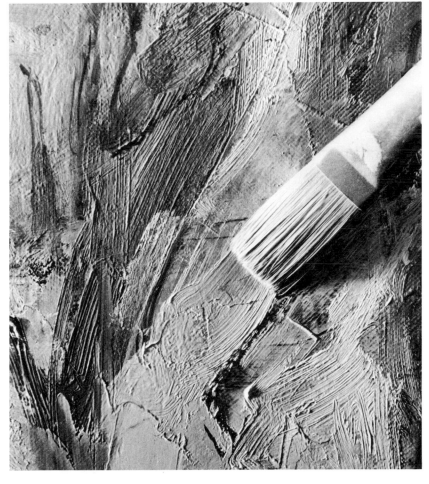

LONG BRISTLE BRUSIIES. Switch from the soft hair of sable brushes to bristle brushes when you want to transfer more paint from the palette to the canvas. The long bristle brush is flexible and can be used vigorously and effectively in areas that call for long brush strokes, such as backgrounds, draperies, and garments. It's good for scumbling paint into darker glazes. The paint should be mixed with enough medium to make it soft. The brush must be filled with pigment, or it will pick up paint from the canvas rather than deposit it. The bristle brush leaves a rough impression on the canvas, and such texture isn't always desirable, such as in skin areas.

ROUND BRISTLE BRUSHES. When the round sable brush is too soft to penetrate or add paint to a given paint stratum, it is best to use a round bristle brush. It will draw into heavy pigment without destroying the surface and won't mix the paint it is carrying into surrounding wet areas. It's a good brush for painting hair, delineating garments, and adding accents to folds. You can produce different effects by varying the strokes. A round bristle brush will scumble into a glaze that has been applied with a sable brush. It won't carry a lot of paint, and it should be used in the finishing stages of a painting. The round bristle brush will take on a new shape from extensive use.

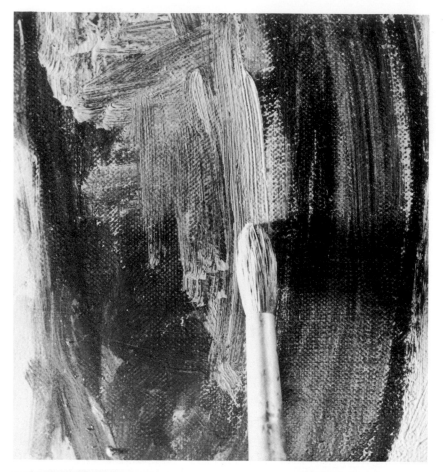

OLD BRISTLE BRUSHES. As time progresses and certain brushes are used more than others, they begin to change their shape. Some of the hair may break or fall out. Such changes make these brushes highly desirable. Old brushes add individuality to the surface of a painting as you invent new uses for them. The unreliability of these brushes is what makes them fun to work with: they surprise you. You may intend one result, yet achieve something that is outside the realm of your usual style. The more new brushes you turn into old ones, the more variety you'll add to the textures of your paintings.

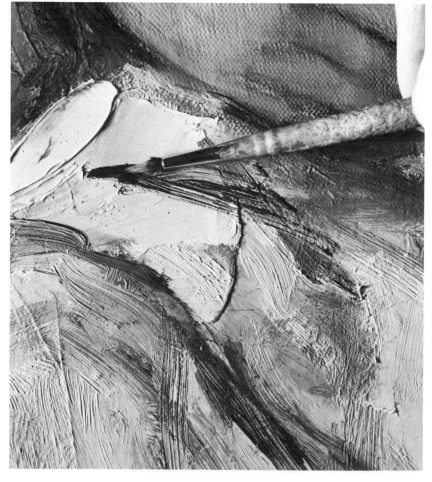

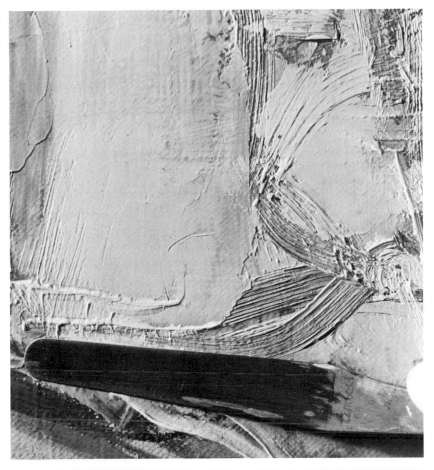

ROUND PAINTING KNIFE. The short round painting knife has a blade approximately 3½ to 4 inches (9 to 10 cm) long. It is used mainly for underpainting, but you can also use it as a priming knife to apply heavy impastos in a final paint stratum. It should be only slightly flexible; otherwise it would be apt to pick up paint rather than deposit it. This knife should be used instead of a brush when you must cover large areas of canvas with paint. Before the paint is applied, it should be blended well with a blending knife to ensure a smooth and even consistency. The knife should become an extension of your hand. Hold it lightly, but be sure to control the stroke. Think of spreading butter onto brittle toast without breaking it and you'll have the right motion.

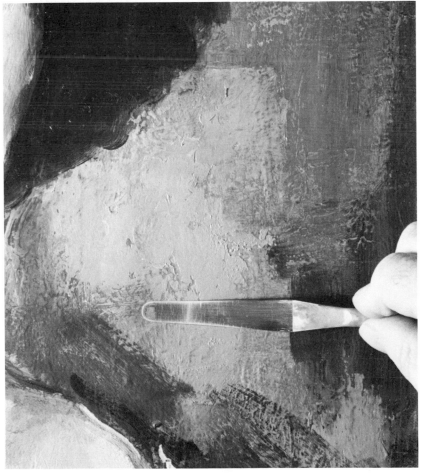

SMALL PAINTING KNIFE. The small painting knife has a rounded blade that's only slightly flexible. This knife is good for priming and underpainting the canvas in the early stages of a grisaille. It can also be used to scumble heavy impastos in the final stages of a painting. Load the knife with paint, apply it to the canvas, and move it in the desired direction. Leave such applications alone until all surrounding areas have been painted. You may then wish to blend the heavy pigment with other areas or leave the heavy impastos untouched.

In the illustration you can see traces of various applications—those of the sable brush in the lower left corner, the short and long bristle brush strokes in the upper right corner, the thin line produced with the pointed painting knife in the lower left corner, and finally the stroke of the small painting knife, with heavy impasto adding weight and a change of texture to this passage.

POINTED PAINTING KNIFE. When all the tools that produce impastos and scumbles have been used (flat sable, long bristle, and short bristle brushes and the round painting knife), bring in the pointed painting knife. It should have a flexible blade, 4½ inches (11½ cm) long. Because it delivers only small amounts of paint, it should be reserved for details. It would be used, for example, to apply the final touches of heavy impasto to skin, or wherever a sculptural effect is desired. The paint should be applied and left undisturbed. As shown in the illustration, the strap has been left to stand out for a three-dimensional effect in contrast to the rest of the garment, which was blended into the surrounding areas. This knife has a tendency to encourage bravura, so beware and use it with discretion.

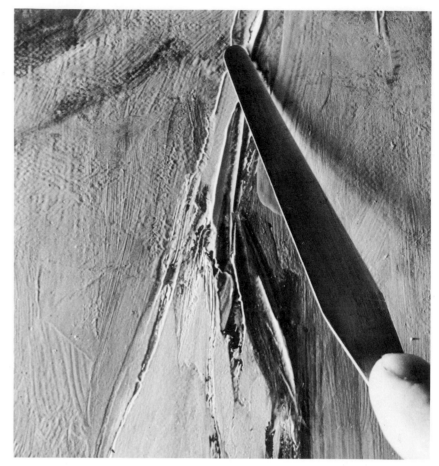

LARGE BLENDING KNIFE. The blade of a blending knife should be soft, flexible, and about 4½ inches (11½ cm) long. The word *blend* describes the motion that is required for using this knife to smooth heavy applications of paint and the patterns left by brushes. Such strokes should be light, barely touching the surface of the paint. In the beginning you may find that your fingers get in the way, but once you've mastered the tool, its motion becomes second nature. It produces a smooth surface that is especially suitable for skin. The blending knife is also used to scrape lightly over overpainting, to lift some of it so that the underpainting becomes visible. Of course, you can also use the blender to scrape and erase passages you aren't satisfied with. Finally, use it to scrape the center of your palette at the end of the day. The more you use this knife, the thinner and more versatile it will become.

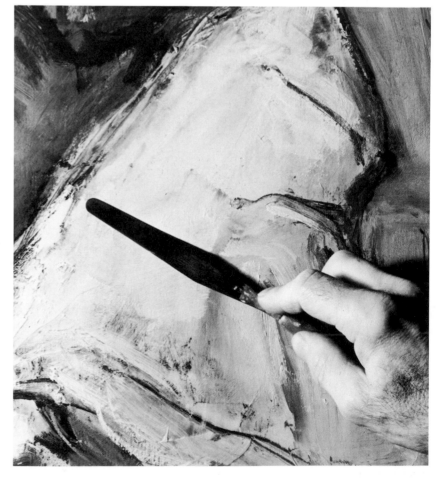

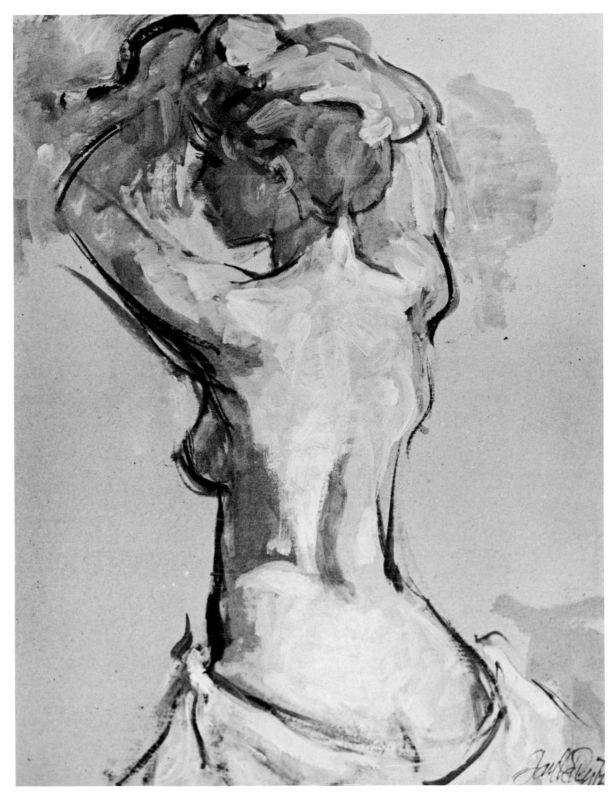

THE BATHER, 30″ × 20″ (76 × 51 cm). Private Collection.

It's always important to "catch the mood of the day," to be aware of your response to the model, and to sense your own dexterity, for this varies from day to day. You may approach your painting with the mood of the previous day, yet a new feeling may take over. Be aware of the change and make the most of it.

In this oil sketch, for example, the spontaneity comes not from technique, but rather from the feelings of the day. The painting was done on an absorbent cardboard surface which imposed a need for spontaneity. The drawing was done with a round sable brush, using cobalt blue and medium. The dark areas of the skin were painted with ultramarine blue, yellow ochre, and white and the light areas with yellow ochre and white. Only a few areas of the background were touched with accents. Observe the hands; they are barely defined, yet they indicate their action. The drape was painted in shades of white with raw umber added, for variety and to round out the painting. If the subject's behind had been left undraped, it would have created the impression that she is seated on the frame and distracted the eye.

CHOOSING YOUR COLORS

One of the major aspects of a painting's seductiveness is color. When one thinks of painting, color, more than anything else, comes to mind. No one aspect, however, be it drawing, line, composition, shape, or color, should outweigh another. All must be in complete harmony. If a painting is notable for its unusual composition, or if the color receives more praise than the other components, the artist has missed somewhere. A painting should never arouse the intellect, but only the emotions of the viewer.

FLAKE WHITE OR WHITE LEAD

This is the only white I use. It has the least amount of oil among the whites, and it dries rapidly. Both qualities make flake white a perfect priming, underpainting, and overpainting color. Since flake white has less oil in it than other whites, you can more effectively control its consistency with medium. The consistency of flake white may vary from one manufacturer to another, so experiment with several brands to find the most suitable one.

REDS

VENETIAN RED. Medium drying time; opaque. Venetian red is perfect for underpainting skin tones; when mixed to a light pink with white, it makes a cool, classic red. You can't go wrong when using it in the vicinity of skin tones. It takes on a brilliant quality (for it has a subtle hue) when scumbled into viridian green.

INDIAN RED. Slow drying time when applied heavily, medium drying time when applied thinly; opaque with some transparent quality. This paint is good for underpainting areas that will later be any kind of blue or black.

CADMIUM RED LIGHT. Slow-drying; opaque. Cadmium red light can be used as part of the mixture for skin tones, but you should add only a speck of it to white and yellow ochre. On other areas use cadmium red light only over a green underpainting (chromium green). Cadmium red light glazed with alizarin crimson gives a truly rich red.

ALIZARIN CRIMSON. Slow-drying; transparent. Because of its transparency, alizarin crimson lends itself to glazing; but don't get carried away by the temptation to glaze all over. There's nothing duller than a canvas full of alizarin glazes.

MARS VIOLET. Medium drying time; opaque. Mixed with ultramarine blue or cerulean blue and white, Mars violet offers a warm gray. It has an extremely strong tint that should be used sparingly.

The color is a good underpainting for blues and for areas that will appear in greenish tones.

BLUES

PRUSSIAN BLUE. Medium drying time; transparent. Being the most intense of all tints, Prussian blue tends to dominate when mixed with other colors. Use it only on areas that will dry completely before a new paint layer is applied, or as a glaze on dry areas.

ULTRAMARINE BLUE. Medium drying time; semi-opaque. Ultramarine blue should be used when mixing skin-tone glazes. Mixed with raw umber and white, it offers grays of various degrees; with burnt umber, a facsimile of black. It's not an exciting or intense color unless it's set off by other blues.

CERULEAN BLUE. Medium drying time; opaque. Cerulean blue is a strong blue, yet light and extremely cool. Use it rather than white to highlight other blues. With a touch of white, it's a good color for glazing skin tones.

COBALT BLUE. Slow drying time; semitransparent. Although cobalt blue is actually opaque, its consistency is so gentle that only when applied by scumbling or on dry areas does it retain its luster. When painted on wet areas, cobalt blue sinks in and loses its luster as it dries. Mixed only with white, it turns chalky and becomes inconsequential.

PHTHALOCYANINE BLUE. Medium drying time; transparent. Phthalocyanine blue has very much the same tint as Prussian blue, yet it's somewhat on the sweet side and, when mixed, lacks the intensity of Prussian blue. Mixed with yellow ochre and a touch of black, it produces a sharp green suitable for accents.

GREENS

CHROMIUM OXIDE GREEN. Medium drying time; opaque. This is a good color for underpainting areas that will eventually be done in warm tones.

VIRIDIAN GREEN. Medium drying time; transparent. Since viridian green is primarily a glazing color, it's extremely useful. When mixed with a touch of white in a glaze, it's perfect for skin areas.

PHTHALOCYANINE GREEN. Medium drying time; transparent. This color is highly intense and should be used with discretion. It's good for glazing areas into which you plan to scumble with red. Phthalocyanine green is really an accent color unless you're treating the whole canvas in cool tones. Mixed with burnt sienna, it produces a subtle, rich

shade of green. Mixed with cerulean blue, it offers an extremely strong accent color.

YELLOWS

CADMIUM YELLOW MEDIUM. Slow-drying; opaque. Cadmium yellow medium responds very much like cadmium yellow light. It's a good color for underpainting an area that will eventually be scumbled with a lighter yellow.

CADMIUM YELLOW LIGHT. Slow-drying; opaque. Cadmium yellow light is ideal for producing effective green tones. I recommend these mixtures because I would never use a green directly from the tube. Although all tube greens are green, not one of them looks like any green I've ever observed in nature. Glazed with cadmium red light, cadmium yellow light produces a luminous orange.

BARIUM YELLOW. Slow-drying; opaque. Mixed with a speck of cadmium red light, barium yellow produces a subtle orange; mixed with white, it's handsome on draperies. Barium yellow should not be applied unless there's a warm underpainting underneath, because it's too light to survive a cool undertone; the yellow will turn light green.

NAPLES YELLOW. Slow-drying; opaque. Naples yellow is very handy for skin tones. It's a good color to mix with white when underpainting draperies that will eventually appear white.

YELLOW OCHRE. Medium drying time; opaque. Yellow ochre is ideal for skin tones.

MARS YELLOW. Medium drying time; opaque. This is a good color for background areas. Mars yellow mixed with a touch of cadmium red light, black, and white produces a tone similar to a cool raw sienna, but it's stronger, more opaque, and capable of being cool or warm in various degrees. Mars yellow is a good underpainting tone when you want to glaze with Prussian blue to form a subtle, rich green. It's also good as an underpainting when you plan to glaze with black.

CADMIUM YELLOW DEEP. Slow-drying; opaque. The tint is close to an orange when mixed with a touch of cadmium red light.

ORANGE

CADMIUM ORANGE. Slow-drying; opaque. Cadmium orange lends itself to some very rich combinations through mixing. With ultramarine blue deep, you can obtain a mellow green of various degrees, depending on how much blue you add. Mixed with black, cadmium orange produces a rich olive green which, after it dries, can be glazed with Prussian blue.

EARTH COLORS

RAW UMBER. Fast-drying; semi-opaque. This cool brown is extremely helpful as a dryer; some raw umber added to an underpainting will facilitate drying while altering its color only slightly. Raw umber is a good color for sketching with a sable brush and for glazing shadows when you prefer a monochrome shadow. When mixed with ultramarine blue or Prussian blue, raw umber produces an equivalent of black.

BURNT UMBER. Fast-drying; semi-opaque. Burnt umber reacts much like raw umber, except that it's warmer and more intense. Use it only when you need those qualities.

BURNT SIENNA. Fast-drying; semitransparent. Burnt sienna is ideal for sketching on canvas with a sable brush when you want to reestablish the drawing. It's an ideal glazing color over areas where slight warming is needed. Mixed with ultramarine blue, it makes the richest deep green available.

RAW SIENNA. Medium drying time; semitransparent. Raw sienna succumbs easily to other colors when mixed, so it can make colors muddy without adding any interest. It's wonderful for glazing.

BLACK

IVORY BLACK. Slow-drying; opaque. I've often heard that a painter should never use black, but I've never heard a truly logical reason for not using it. There's something elegant and dramatic about black; however, you should use it for accents only. When you want large areas of black, underpaint first with Indian red. When this underpainting is dry, glaze with black, first over the whole surface, then intensify the glaze in dark areas. The red glow will take the monotony out of the black. If you want light areas on the black surface, wait for the glaze to dry, then apply a glaze of black with a touch of white added. This glaze, although somewhat opaque, should still allow some of the red to show through.

MY OWN PALETTE

I use these colors on a kidney-shaped palette:

Flake white	*Mars violet*
Yellow ochre	*Barium yellow*
Naples yellow	*Cadmium yellow medium*
Mars yellow	*Cadmium yellow deep*
Raw sienna	*Zinc yellow*
Burnt sienna	*Cadmium orange*
Raw umber	*Ultramarine blue*
Burnt umber	*Prussian blue*
Ivory black	*Cerulean blue*
Cadmium red light	*Cobalt blue*
Venetian red	*Viridian green*
Indian red	*Chromium oxide green*
Alizarin crimson	*Phthalocyanine green*

MIXING COLORS

MIXING SKIN TONES. The skin tones you select will always be determined by the tone of the under-

painting, which sets the general mood for the overall painting. Although skin tones vary from person to person, even from area to area of the anatomy, you must ignore these imperfections in order to create a harmonious reality of skin tones in your painting.

Always keep in mind that when you paint the skin, it must be done in good taste. "Good taste" means a subtle arrangement of color. Cool tonalities will prove the most successful starting point for such arrangements. And the colors you select, with discretion, should harmonize with the subject matter.

There's no way of painting skin by mixing cool and warm colors and then applying them in an opaque fashion. Mixing warm and cool colors while they're wet will produce a muddy gray, whether they are mixed on the palette or on the canvas. Sometimes warm or cool mixtures even become chalky through excessive use of white. Therefore, you must apply the colors in stages, beginning with either cool or warm, allowing each stratum to dry. Then, by glazing, overpainting, scumbling, scraping, and blending, you can add opposing colors, giving each layer an opportunity to play its part in the final surface of color and texture.

OVERPAINTING MIDDLE AND LIGHT SKIN TONES. Yellow ochre and white applied to either a cool or a warm underpainting will produce the most satisfying results for skin tones. Skin isn't pink or yellow; and obviously it isn't green, blue, or gray. But skin does tend to reflect surrounding hues. On a cool underpainting, you might add a speck of cadmium red light or Venetian red to the ochre and white. Both colors are intense, however, so add only a speck and no more.

GLAZING SHADOWS ON SKIN TONES. For the shadow areas of skin, you'll find the most frequent use for glazes consisting of ultramarine blue and yellow ochre. Again, you might add a touch of cadmium red light or Venetian red mixed with white to a grayish tone. Keep the mixture on the cool side for a warm underpainting. The shadow parts of a warm underpainting can also be glazed with a mixture of burnt sienna and white. This is a simple procedure; you'll find it used in Demonstration 1, page 62.

PAINTING SHADOWS ON MATERIALS. To paint shadows on objects, draperies, or garments, underpaint in the color you desire, then glaze the shadow areas with raw umber, intensifying the glaze in darker areas. Although this is a safe way to paint shadows, it can be monotonous if used without discretion. Various glazes will produce good shadow colors. Always be sure that the underpainting remains visible (unless the shadow is extremely dark or unless such darkness is needed as an accent).

Here are a few combinations of underpainting and glazes that work well:

> *On yellow: very thin raw umber mixed with a touch of white*
> *On red: viridian green or raw umber*
> *On green: raw umber, or raw umber and ultramarine blue; Prussian blue, only if the surface is completely dry; even a black glaze can be extremely effective*
> *On blue: ultramarine blue and raw umber; again, black is also highly effective*
> *On ochre or Mars yellow: raw sienna glaze with raw umber added to dark areas*
> *On white: raw sienna and a touch of cerulean blue with some white added, or a very light glaze of raw umber*

Once you have mastered your palette, you will be able to give free rein to your feelings and their expression.

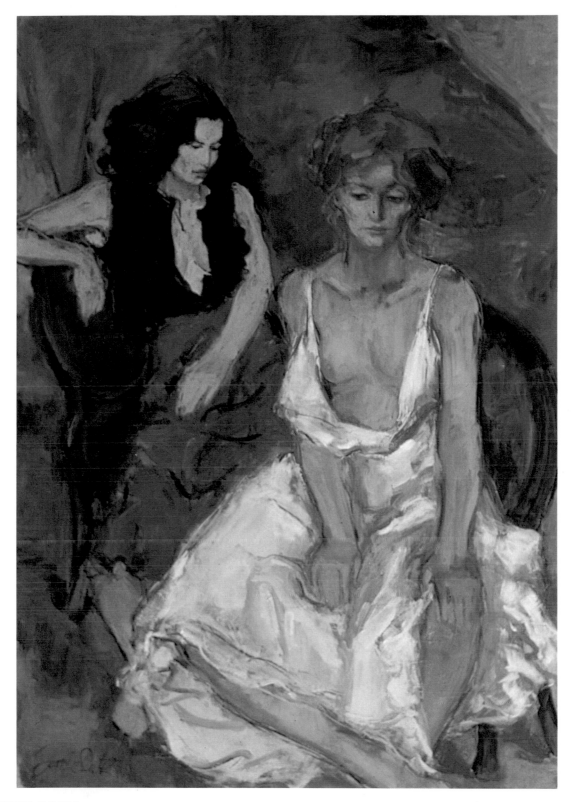

DRESSING ROOM, 40″ × 30″ (101½ × 76 cm).
Courtesy Tyringham Gallery, Tyringham, Mass.

In working with color, the artist must always think on two levels. He must concern himself not only with the role that colors will play in the composition, but also with their quality. The first problem is to determine variety, form, and balance. The second problem is to ripen the colors by means of underpainting and overpainting.

In this painting there is a strong red diagonal made up of the two chairs, the skirt of the rear figure, and the background. The other prominent "colors" are white and black. The figure in white in the foreground contrasts with the black hair and blouse of the background figure.

What makes the use of these white and black "colors" effective? Neither the white nor the black is a "pure" tint. The white was underpainted in pink and then glazed with Naples yellow, raw umber, and white. By glazing and then scraping to reveal some of the underpainting, I created many "shades" of white. The areas that are actually white are few, and they were applied with a knife to emphasize their importance. It is really all the other colors, both those surrounding the white and those within the white, that make the "white" appear white.

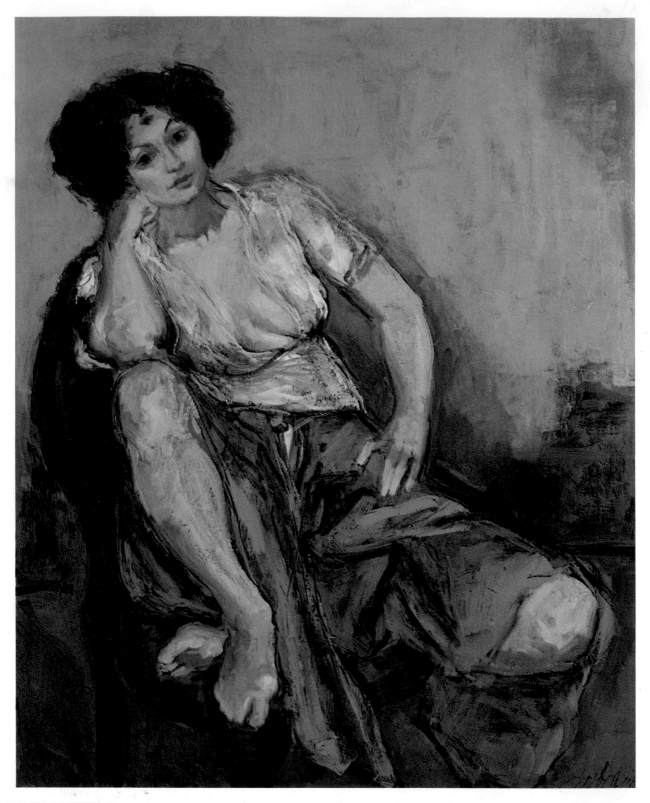

FANTASYWORLD, 40″ × 32″ (101½ × 81½ cm). Collection of Mr. and Mrs. Barry Griffiths. Courtesy Gallery 306, Philadelphia, Pa.

I placed the model's dramatic pose precisely in the square of the canvas. Then I chose to let the balance of color flow into the strong gesture of the pose. The round form of the chair complements the rather angular pose of the model.

The blue is underpainted with red; the yellow, with a light red, close to pink. The overpainting mixture and its fluctuating color were brought about with various shades of yellow mixed with white to very light hues. Using different knives and brushes, I scumbled these tones into a light orange glaze, then scraped and blended. The blue of the skirt is a mixture of cobalt, cerulean, a touch of viridian, and white scumbled into a light Prussian blue glaze. These heavy impastos show the weight of the material as well as its clinging quality. Some of the warm underpainting must always show through to bring richness to a color that might otherwise be dull. The background is in neutral grays. Of course, these grays are painted over various shades, so that every aspect of the background color and the figure are of equal strength.

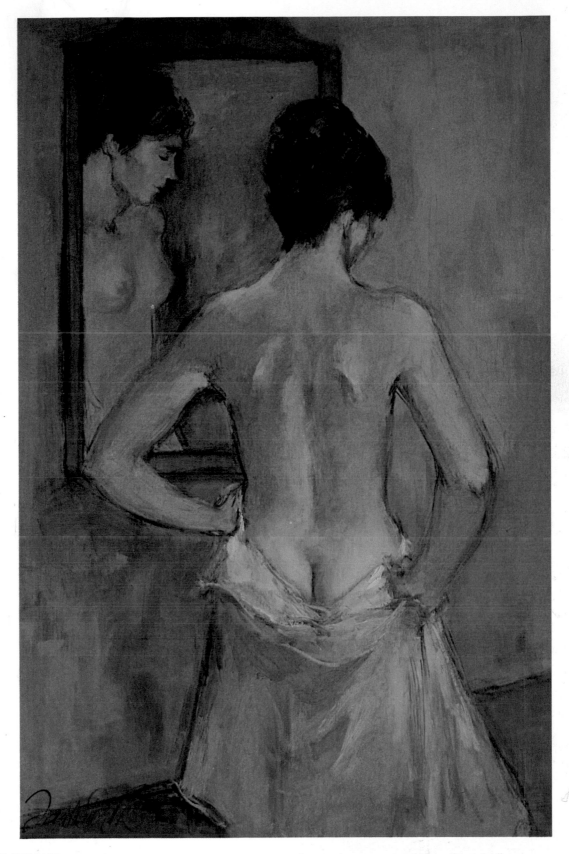

REFLECTIONS, 33″ × 23″ (84 × 58½ cm). Courtesy Gallery Beatrice Zarges, Munich, West Germany.

"Good taste" probably has as many definitions as there are tastes. In a painting, color can lend an element of good taste to a subject that might otherwise be thought to be in "bad taste." A provocative pose, for example, painted in warm or hot colors would offend the viewer. The same pose rendered in cool tones becomes more acceptable, or "tasteful."

Reflections is painted in cool tones. It's simple in both line and color. Although the colors of the figure would not normally be used for skin, the skin is warmed by the even cooler tones of the surrounding areas. Some parts of the figure are painted in the same shades, and only a drawing line divides the figure from the background.

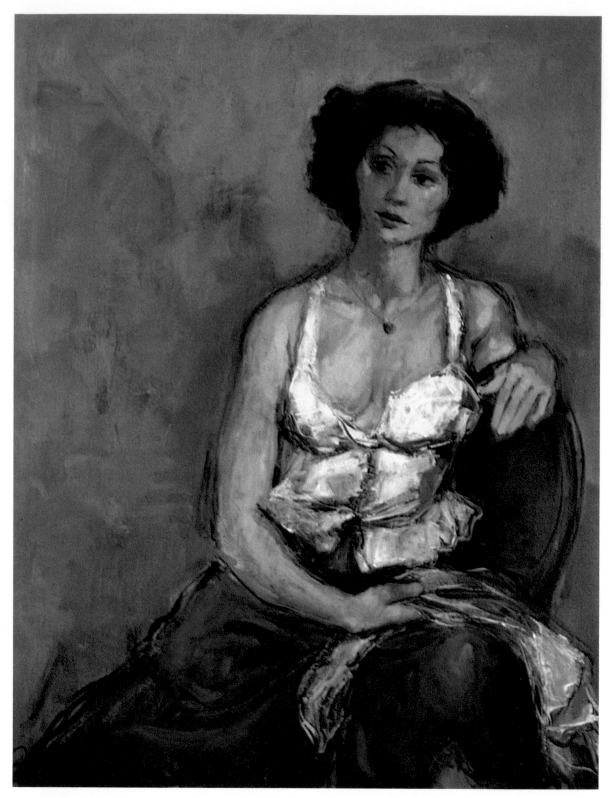

THE PENDANT, 40″ × 30″ (101½ × 76 cm).
Collection of Mr. and Mrs. Joseph Idy.

I did the underpainting of this work with oil pastels. When the paint was dry, I glazed the shadowed areas of the skin, using a sable brush, treating everything—brush, paint, and canvas—with a light hand. The lighter skin tones were painted with a bristle brush and painting knives. I surrounded the figure with a light glaze of Prussian blue into which, using a painting knife, I scumbled shades of gray. I took care to repeat each application of color in another area of the canvas to achieve balance of color and form. I blended skin tones into the background and back-

ground colors into the figure, and finally I reestablished the outlines of the drawing with a scriptliner.

I glazed the shadowed parts of the blouse. Into these glazes I first brushed the pigment with a sable brush, then scumbled a lighter shade. Using a pointed painting knife, I raised the scumble in some areas and scraped it in others. With a sable brush I glazed the skirt, then scraped away some of the glaze to allow the underpainting to show through. The piece of material in the model's hand was an afterthought which I added for interest and to give purpose to the gesture of the hand.

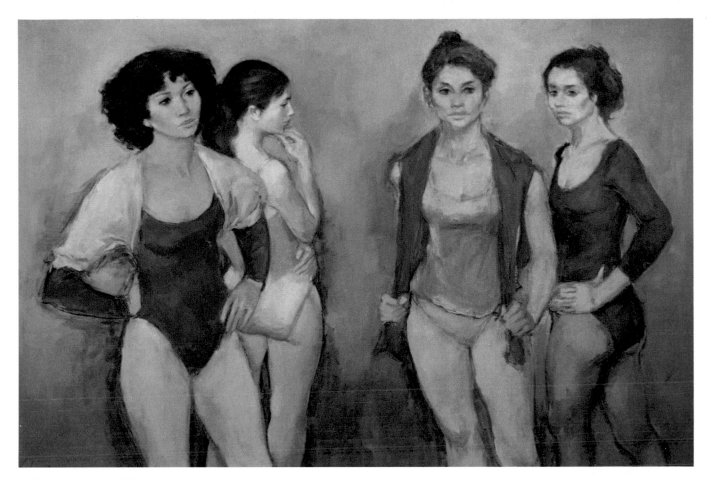

THE CALLBACK, 38″ × 48″ (96½ × 122 cm).

There are two very good approaches with which you can arrive at a balanced yet dramatic color scheme. One is to build up colors slowly from a rather subtle palette, then add stronger colors, balancing the composition with tints of similar strength on other areas of the canvas. This is the safe way, and it almost always leads to satisfactory—and safe—results. The second method is a little more challenging, but it carries with it the rewards of persistence. The system itself is simple: start the painting with an area of strong color, then surround that color with equally strong colors. Of course some colors have to be more subtle and some have to recede, or the painting would be monotonous regardless of how rich the colors are.

In *The Callback* I started with the yellow T-shirt on the figure facing the front. I underpainted with oil pastels in two shades of light red. The overpainting was done with alkyds. The yellow is a mixture of cadmium yellow with a touch of white. I glazed with this yellow over the whole shirt, then scraped some of the glaze to allow the red underpainting to strengthen the yellow. With a painting knife I applied heavy scumbles of the same hue in areas of light. I now had a strong color on a figure with a strong posture. After that I added strong colors on each figure to arrive at a color composition that is both rich and balanced.

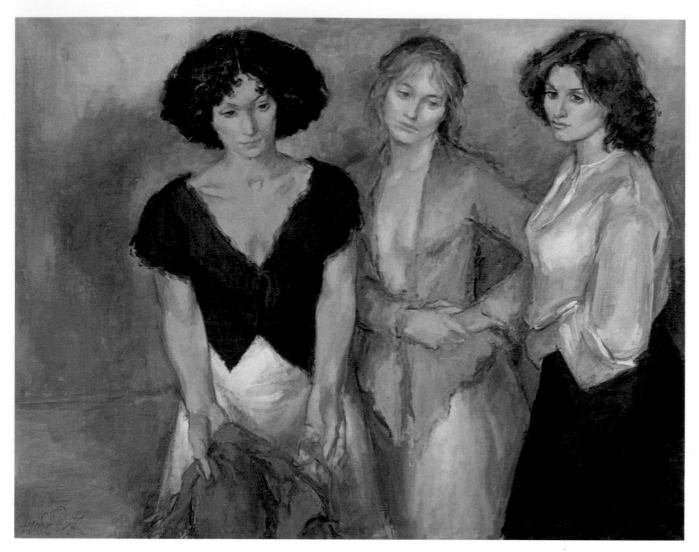

VARIATIONS, 33″ × 43″ (84 × 109 cm). Collection of Mr. and Mrs. Frederic Altman.

An important feature of this painting is the contrast between the stark color of the figures and the softness of the background colors.

There are three whites—two skirts and a blouse forming the strongest diagonal line. The black blouse is balanced by the black skirt. The pink blouse on the middle figure is almost neutral.

The background begins in very cool tones in the right upper corner and ends in very warm tones in the "empty space" on the left side of the canvas. All these tones were achieved by underpainting, glazing, overpainting, scraping, allowing the underpainting to show through, letting the canvas dry, and adding new, more subtle colors, adjusting them to the figures, and adding darkness or light to make contrasts and to blend with the figures.

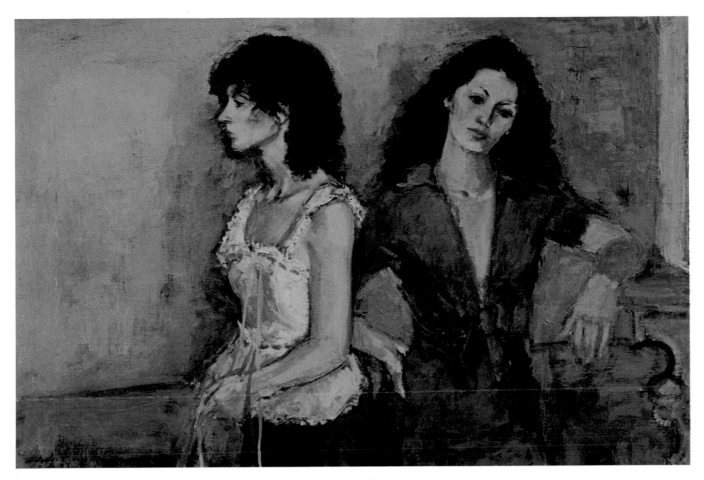

RIBBONS, 24″ × 36″ (61 × 91½ cm). Courtesy Florence Art Gallery, Dallas, Tex.

Mars violet is the basic color used for shading the blouse of the model leaning against the fireplace. This color in itself is extremely intense, and unless it is toned down, it leads a painting into the purple sphere and becomes too sweet. It is a color that might evoke sentimentality, which is the last thing an artist should strive for; sentiment, yes, but not sentimentality.

I underpainted the blouse in blues, glazed a little in the shadow areas with a light Prussian blue. I then applied three shades of Mars violet mixed with a touch of alizarin and white, then scraped to allow the blue to shine through. The coolness of the blue thus balances the "purple" of the Mars violet. The skirt on the other figure was painted with alizarin crimson, which balances and subdues the Mars violet blouse.

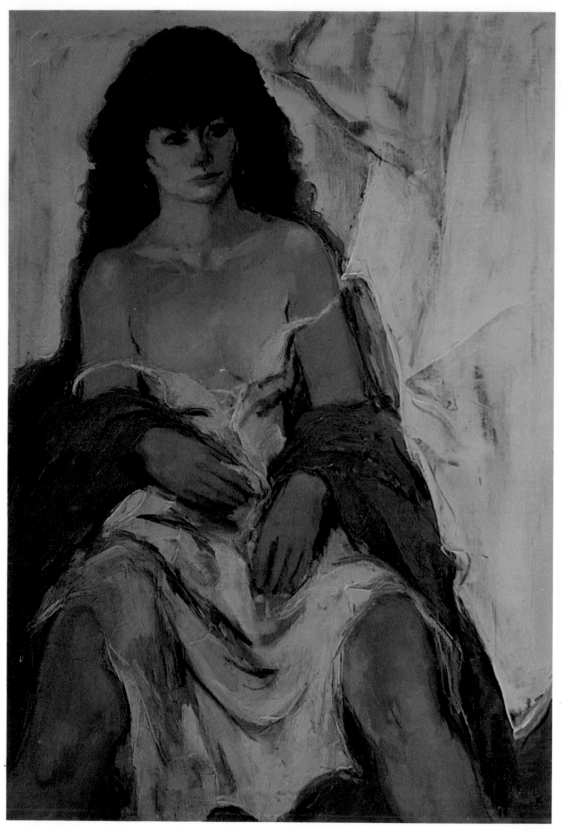

CIRCUS GIRL, 33″ × 23″ (84 × 58½ cm).

Yellow is an extremely appealing color; it can be soft and receding or strong and boisterous. The position of the figure in *Circus Girl* is strong and needs a strong color complement. Even the white drape, which for once is almost pure white, is persuasive in its "color." In each case I applied heavy impastos. The warm underpainting beneath the yellow background is almost invisible. The underpainting beneath the white shows through in some areas to add life. The garments were painted with heavy impastos, even heavier and less blended than the background. The linear colors are mixtures of cobalt blue and phthalocyanine green, which add strength to the painting with their forceful application.

Never compromise your feelings in a painting. Let your subject be beautiful or grotesque, weak or strong, but never in between. Your own convictions will persuade the viewer.

40

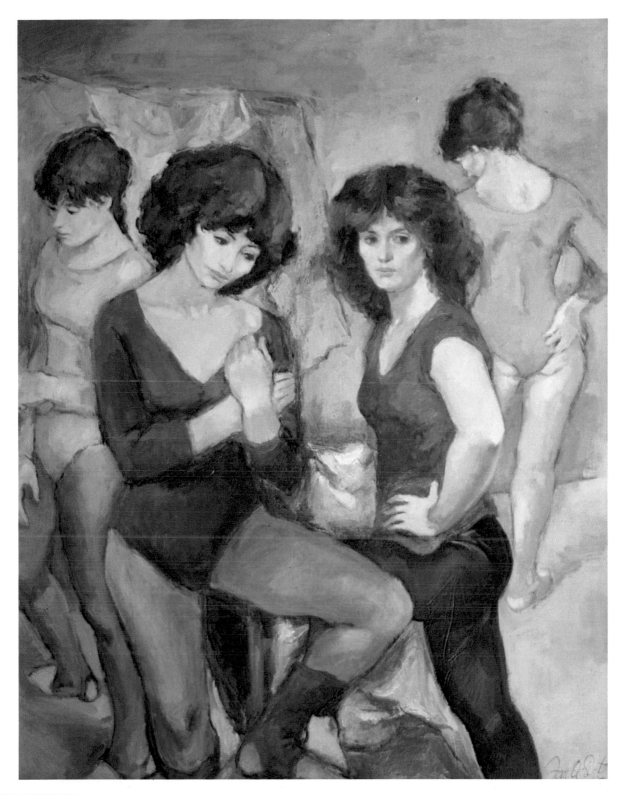

THE STUDIO, 44″ × 34″ (112 × 86½ cm). Courtesy Florence Art Gallery, Dallas, Tex.

If you paint a single figure, most times it is a simple procedure to work out the composition in terms of placement, form, line, and color. Once you start adding figures, the problem becomes more complex. One really does not know what the finished picture will look like until all the figures are in place. To the onlooker, the completed painting should seem effortless, or it will be distracting. If just one figure is out of place, the painting will upset the viewer. This does not mean that the figures must communicate, but there should be an interplay between them.

In this painting the four dancers have a common ground, the studio; it is natural for them to be together. The safest way to hold them together is to let them "cut" into one another. If one takes a strong stance, another should strike a pose or similar strength. In *The Studio* it is the poses and the colors that hold the figures together. The two figures in front interact in both posture and color. The red of the warm-ups, over the viridian green of the tights, adds a touch of excitement to an area that might otherwise be dull. The rear figures are painted in soft colors to blend with the background. The yellow of the garment draped over the screen is repeated more strongly on the front figures, thus forming a relationship between foreground and background.

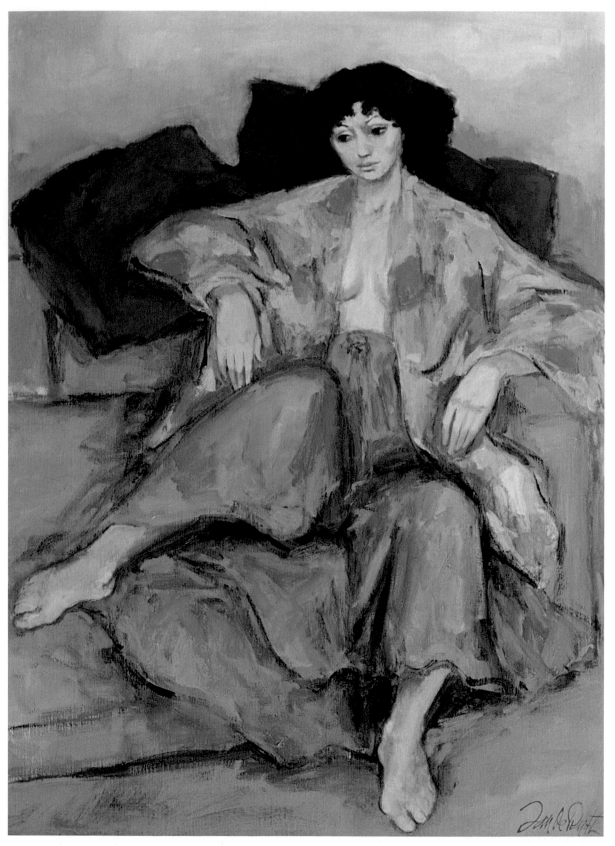

YELLOW KIMONO, 40″ × 30″ (101 × 76 cm).
Courtesy Gallery Beatrice Zarges, Munich, West Germany.

When painting a printed material, be it intricate or simple, the best way to proceed is first to paint the garment to its finished stage without the pattern, using the most dominant color. Once all lines, folds, darks, and lights have been established, you can impose the pattern of the print. When the print is safely dry, you may then glaze with an appropriate color over the shadow areas. You may want to lighten some areas where the light is particularly strong.

The pillows in my studio are actually covered with patchwork, but by adjusting reality and painting the pillows in the same color, I balanced the composition and focused attention on the figure.

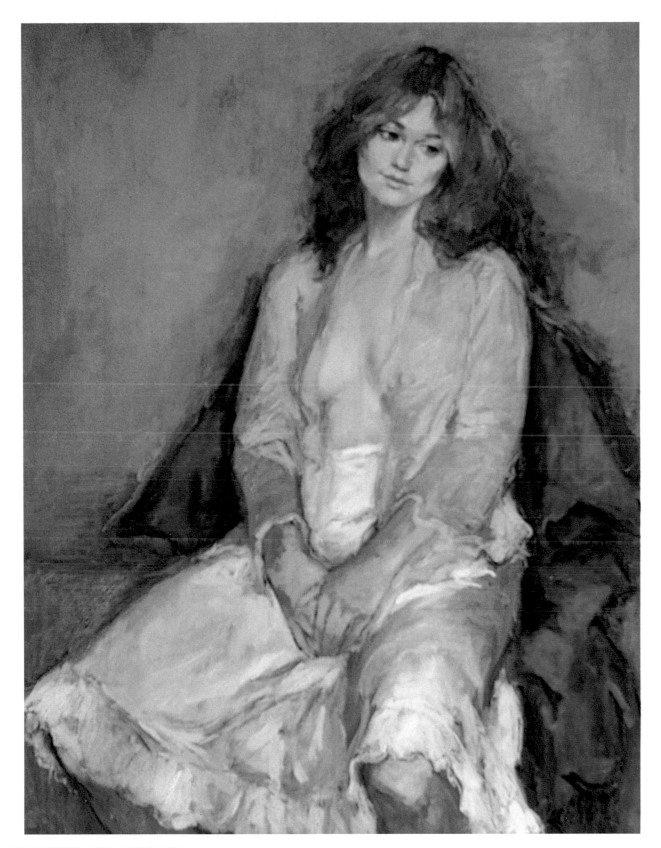

FAR AWAY AND LONG AGO, 40″ × 30″
(101½ × 76 cm). Collection Mr. and Mrs. Jay Oberst.

"Pastel colors" are synonymous with fashion. When they are applied to a painting, I get a little leery. Pastels somehow imply softness and sweetness that could easily lead to a weak painting. Women and children usually look good in pastel colors; on a man they appear effeminate and somewhat tasteless. The best way to paint such colors is to be true to their special qualities, which are softness, gentleness, and ability to please the eye.

I used the model's pink jacket as the focal point of this painting, incorporating some of the pink into the white slip. The underpainting of viridian green and white was allowed to show through the blouse. The skin tones were kept in cool hues. I surrounded the soft pastel colors with a rather strong red drape to balance the softness and add drama to the painting. The simplicity of the pose harmonizes with the color composition.

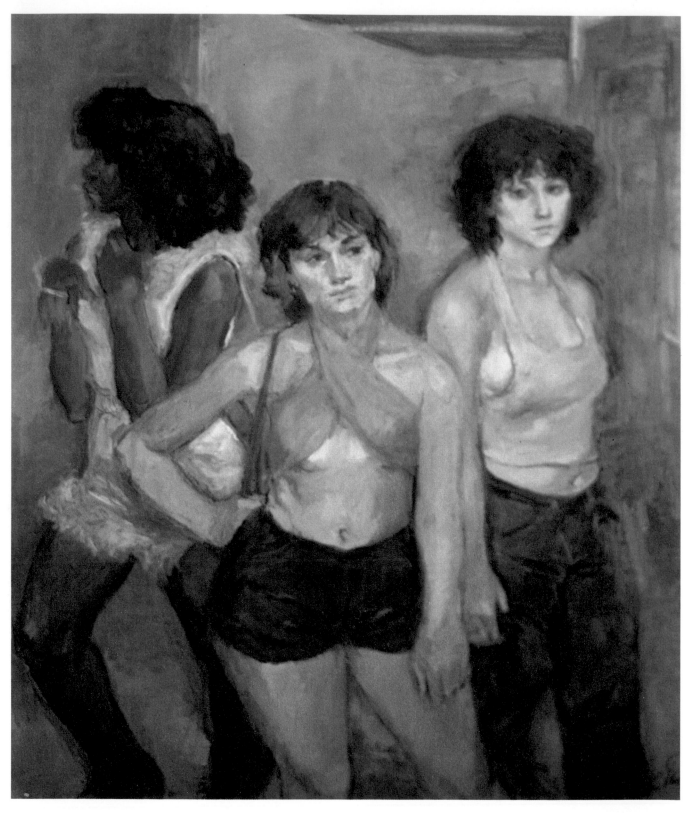

STREET CORNER, 44″ × 34″ (112 × 86½ cm).
Collection of Mr. and Mrs. Frederic Altman.

One should never attempt to "finish" a painting, but rather allow the painting to finish itself. Most times it is the simple adjustment of colors that is the final touch. Would it not be marvelous if we all had a little man or woman sitting on our shoulder who would tap us and say, "Enough"? Too often we overwork a painting, to the point where all feeling is gone, perhaps achieving a perfect surface but one without life and its many ambiguities.

I changed *Street Corner* many times, painting figures in and out. Finally, I had three figures that seemed right. The black figure was very strong in both posture and color; the center figure was strong in expression; and the one on the right was passive in both gesture and color. It was then that the little man on my shoulder said, "Enough; just adjust the colors." I painted the background colors into the scarflike garment that covers the breast of the center figure. I varied the background, adding color to the side that was passive but keeping it simple so as not to compete with the action in the foreground.

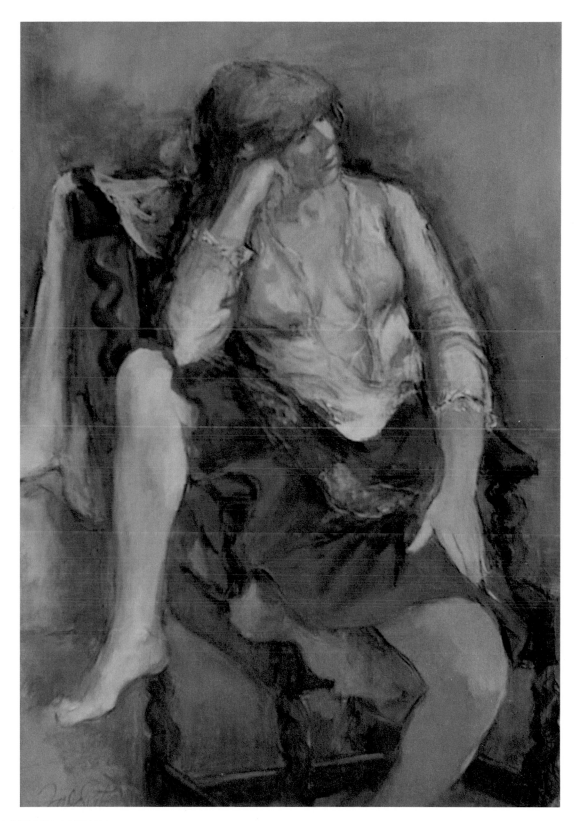

BORROW ME A HOPE, 36″ × 24″ (91½ × 61 cm).
Collection Mr. and Mrs. Janis Krisans. Courtesy Riggs Gallery,
San Diego, Calif.

One way to assure that a painting remains within aesthetic
bounds is to paint the skin color in cool tones. Skin that is
painted too pink will be just that: a pink to reddish area on the
painting. Skin tones must be subtle. The best way to achieve
that is to underpaint the skin in either cool or warm tones and
then overpaint it with an opposing color scheme. The best
mixture for overpainting on a cool underpainting consists of flake

white, a little yellow ochre, a touch of cadmium red light, and a
touch of ultramarine blue thinned to a glaze for shadow areas.
The medium areas should be white, yellow ochre, and a touch of
cadmium red, applied and then scraped so that some of the
underpainting shows through. Make sure the canvas is dry
between the painting stages, for color sets and changes its hue
while drying. It's so much easier to make adjustments after the
painting has been set aside for a few days; once it's dry, you'll
see it with a much clearer eye.

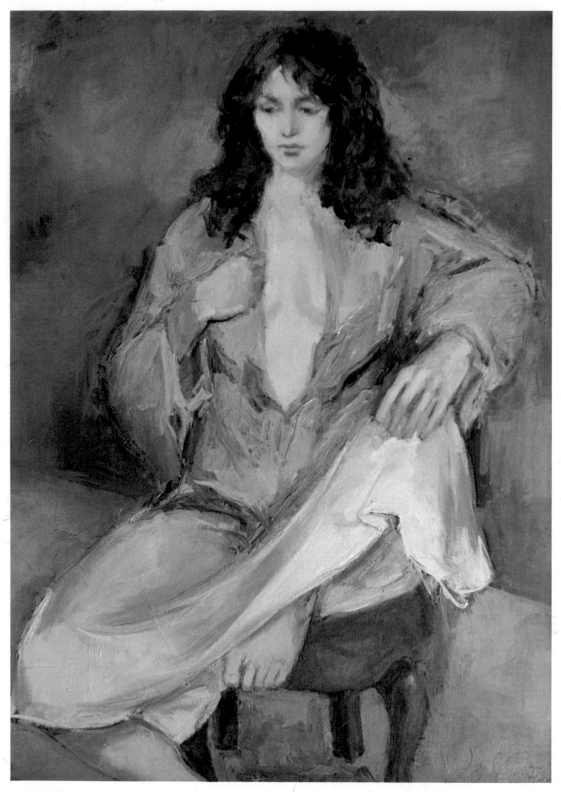

THE ACTRESS, 34″ × 24″ (86½ × 61 cm). Gallery Beatrice Zarges, Munich, West Germany.

When this model arrived, I was faced with a somewhat faded olive green blouse and a skirt that may once have been pink but by then had faded into a kind of gray, neither of which excited my imagination. When the model assumed a dramatic pose, however, I worked with what I had.

As the painting progressed, I brought some of the background colors into the figure and some of the figure's colors into the background. You'll find cobalt blue in the hair, and also outlining the blouse in some areas, but it functions most importantly in the background. Cobalt blue is an electric color; either you use it to its full potential, or you must break its intensity with another color. If you wish to use it fully, be sure that the area you paint on is dry, for it sinks into wet colors and loses its brilliance.

I painted the skin in cool tones, but against the "cooler" tones of the garment and background such cool skin tones are acceptable and natural. Although this painting began with a rather dull color contrast, by experimenting with cobalt blue (normally a taboo color) I balanced the dramatic pose with an equally dramatic color.

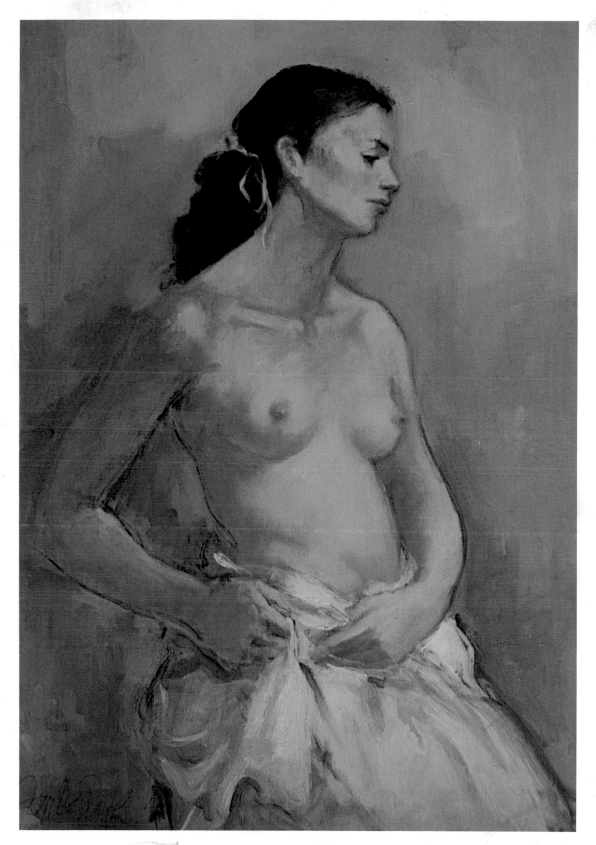

THE TURN, 33″ × 23″ (84 × 58½ cm). Private
Collection.

Blue, in all its colors and shades, is certainly the most
appealing color to paint into backgrounds. Blue is the color of
the atmosphere we live in. Therefore, in our mind and spirit, it's
the color that recedes, that fades, that speaks of distance.

Of course, were we to paint a background in one shade of
blue, we would fail. Blues such as Prussian blue, ultramarine
blue, cobalt blue, and cerulean blue are brilliant. Only when we
change their hue with a warm underpainting, scraping some of
the paint and varying the shading and strength of color to fit the
form and emotional content of the painting, will these blues
recede and become atmosphere or background. By allowing
some of the blue background to appear in the tones of your
figure, you'll unite the figure and background into one
harmonious unit.

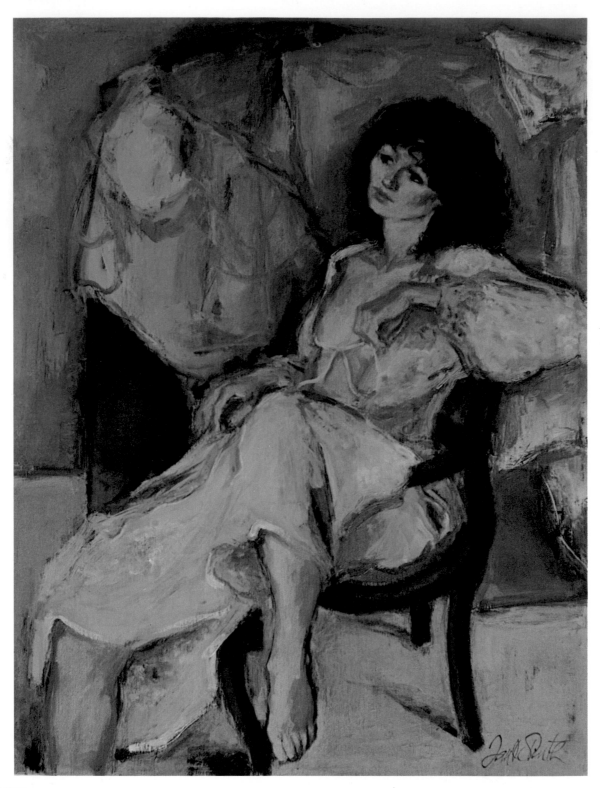

RIMES, 36″ × 28″ (91½ × 71 cm). Collection of Dr. and Mrs. Thomas Czarecki. Courtesy Soufer Gallery, New York City.

When working with models, it is often advisable to succumb to whatever colors they may bring to your studio, even if such personal color schemes may be contrary to your own sense of taste.

Rimes is a good example. Kathleen, the young woman who posed for this painting, arrived with a vast variety of the most delicate of clothes, most of them in hues of purple and pink. Although I personally have an aversion to purple, these colors were truly in harmony with the gentleness of her soul and her spirit. Had I attempted to transfer this reality onto the canvas, I would have ended up with a sentimental painting.

All the colors that you see were underpainted in the warm hues that belong to the pink family. In the second and third sittings, however, I slowly began to adjust these warm colors with cool glazes and scumbles, always permitting the model's favorite colors to shine through on the final surface. I left one area in its original hue, a pinkish blue, above the figure's right shoulder. Of course, the diagonal composition of the figure gives the painting an initial strength that allowed me to play with the surrounding color.

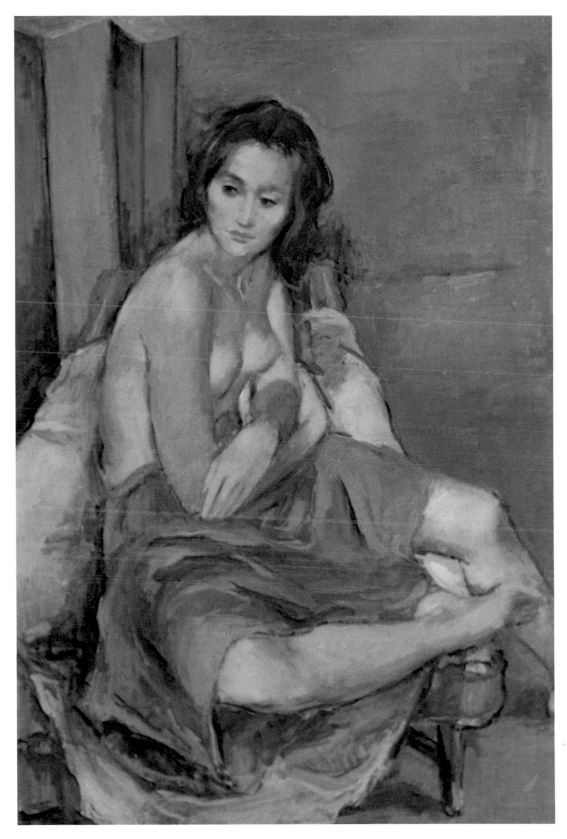

SHADES OF VIRIDIAN, 36″ × 24″ (91½ × 61 cm).
Collection of Mr. and Mrs. Robert G. Millston. Courtesy Soufer
Gallery, New York City.

It is viridian green that holds this painting together. Viridian
green by itself is rather bland, but used properly it can enhance a
painting enormously. Gradations of viridian green, light
yellows, pinks, and white will create a picture of the most subtle
color composition. In *Shades of Viridian* the skin tones are
devoid of red, but painted only with yellow ochre and white,
with a touch of ultramarine blue for shadows. Such a cool skin
tone takes on warmth and naturalness because it's surrounded
by multiple shades of viridian green, fading into blue.

No color should be overused, but rather employed with the
discretion that comes with practice and learning the joy of letting
color weave its way through the texture of the painting surface.

Part Two:
The Painter Prepares

An artist never ceases to observe, to re-create in his mind what he sees in reality. His eyes get sharper and his powers of observation get stronger all the time. For an artist, it becomes second nature to "draw with an empty hand."

POSING THE MODEL

Don't be overly concerned with posing your model; let her assume a pose spontaneously. Making suggestions to the model is usually self-defeating, because in directing her you'll lose the individuality that she can give to the painting. As your drawing progresses, you'll impose so much of your own will on the canvas that you'll be grateful for whatever the model has to offer.

Whenever I work with a new model, I spend hours drawing quick sketches, allowing the model to change position frequently. This exercise accomplishes two very important goals: it gives me a chance to explore every aspect of the model's anatomy, and it gives the model the opportunity to become familiar with her new surroundings, enabling her to feel more at ease. I also like to observe the model during periods of rest, when she is truly herself. Attempting to paint without first going through this procedure can be frustrating. For although the model may present you with what seems to be an interesting pose, it soon becomes apparent that the first pose isn't really the best she can offer.

There may be times when you're faced with a pose that you don't like. In art classes, for example, not everyone will be pleased with his view of the model. It's at times like these that the painter must turn a negative reaction into a positive one. If you succeed, chances are that you'll produce a superior painting.

THE ARTIST'S TWO REALITIES

When painting, you're always dealing simultaneously with two realities: the reality of the subject matter and the emerging reality of the painting. It's the artist's privilege—or perhaps even his duty—to shape and adjust the reality of life to fit the reality of the canvas. As long as the model and the painting are in the same room, the urge to compare the two may be irresistible. But once the model departs, the painting must stand on its own merit.

Although the temptation, or challenge, to re-create reality is perpetual, a painting must have its own reality, its own life. The first step toward this goal is to simplify the subject matter. For example, think of the reality surrounding the model; it's infinite. It doesn't simply consist of the whole interior of the studio; it reaches well beyond the door into the model's character and life. Yet the reality of your painting is finite, confined to the shape of your canvas. You must create a new reality to fill this empty space.

STUDIO FURNISHINGS

A model stand is a primary requisite. It should be 10 to 20 inches (25½ to 51 cm) high and as large as your work space will permit. If you cannot buy a model stand, you can easily make one by nailing some wooden boxes together and putting a plywood top on them. Such a stand should be on casters so that it can be wheeled around the studio. A comfortable couch or sofa and two or three chairs of different character are also helpful. A few colorful pillows will complete your basic list of props.

I also urge you to acquire an electric heater to take care of those days when the oil delivery is late or some other mishap keeps the steam from rising!

NATURAL LIGHT

The best light for painting is light that is strong but diffused. North light, through a skylight or an oversized window, is the most satisfactory. Ideally, the light should enter the studio from a source somewhat above rather than directly even with the canvas. I find that the most advantageous hours to paint are in the early morning and late afternoon. The studio walls should be painted white or off-white, so that they will reflect the window light, thereby producing additional light.

The easel should face the light at a forty-five-degree angle, tilted slightly forward to avoid reflections on the shiny surface of a wet painting.

ELECTRIC LIGHT

For more than twenty years I worked with natural north light and was content. As a matter of fact, I was somewhat disdainful of electric light. But winter days are short, and I lost many hours that could have been devoted to painting. So recently I succumbed and installed "daylight fluorescent lights." To soften their harshness I added some warm bulbs.

When you use electric light, make sure that it comes primarily from one direction: above the model, above the easel, and, if possible, from a high source on one wall behind you. You must, at all costs, avoid working with the sort of light that is produced by a photographer's spotlight. Such sharp, reflected light creates a porcelainlike slickness.

DRAPERIES

You should always keep on hand a variety of draperies in different textures, colors, and patterns. They can be used not only in backgrounds, foregrounds, and areas surrounding the model, but also on the model herself. These materials can also be draped over your studio furnishings to change their colors or shapes. You can derive inspiration from draperies and their patterns, but remember that they must remain incidental in your work.

PAINTING THE CLOTHED OR DRAPED FIGURE

Material, either clothing or drapery, adds interest and variety to a figure painting. Clothes or draperies help to enhance the pictorial aspect of the subject, but when used they must be fully integrated into the painting and never permitted to dominate the canvas.

In reality, clothes form definite shapes, folds, and creases, but if you attempt to reproduce exactly what you see, your painting will be lifeless. It's more important to understand what lies beneath the garments and to indicate that form with a few simple lines. Always look for the fold or crease that's the decisive one and eliminate those that are incidental. Clothes should follow the movement of the body.

THE ROLE OF CLOTHES IN PORTRAIT PAINTING

Ask your sitter to bring a good selection of clothing to your studio. His or her favorite ensemble will probably be a good choice for the painting. If the favored garment happens to be the "high fashion" of the moment, however, it shouldn't be the costume for the portrait. Fashions come and go, and you don't want your portrait to be dated before it leaves your studio.

Never let the costume command more attention than the subject of your painting. Simplicity is the key to a good portrait; the painting should portray the person and nothing else.

The color, cut, and texture of garments, of course, all help to describe the character of the sitter who wears them. The trick is to keep them in perspective so that they don't detract from the central theme.

The same rule applies to jewelry. Simple earrings, a small pendant, a chain, or a ring or two may add some sparkle to the portrait. But beware of ostentatious or elaborate jewelry that will distract the viewer. Balance is just as important in a portrait as it is in any other painting. The texture of the background should be at least as seductive as the brilliance of a diamond.

Evening dresses or ball gowns may be very dramatic, but you should look into alternatives before you choose to paint them. It's important to know where the painting will hang. Formal attire should be used only in a painting that will be displayed in an appropriately formal setting.

When it comes to men, of course, we are defeated before we begin. How much can be done with a button-down shirt, a three-button suit, and a color spectrum limited to gray, brown, blue, and black? Nevertheless, in the hands of a good painter, even the most drab garment can be made to shine.

Make the most of textures, but be cautious with velvet and satin, for they have a way of becoming dominant. Although you may derive much satisfaction from the technical success of achieving certain textures, just be sure that you don't get carried away by it.

When painting children, the choice of costume is much greater. A little girl may be taking ballet classes, for instance, and it's fine to capture that period of her life by painting her in her leotard. Or she may want to show off her first long dress. Even jeans with the right color shirt will do.

In any portrait, the clothes that are worn are of far less significance than the execution of the subject's head and hands and the choice of gesture or pose.

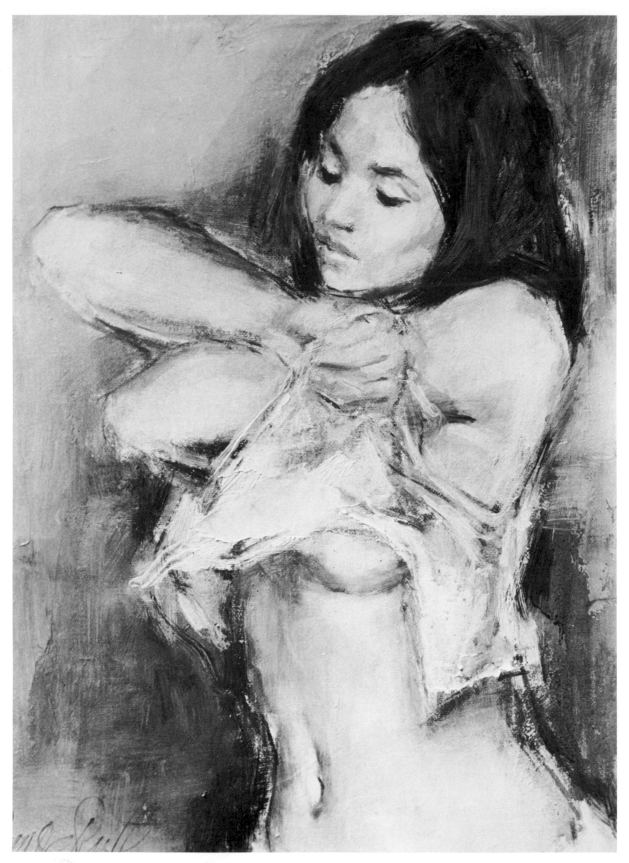

THE LATE HOUR, 16″ × 12″ (40½ × 30½ cm).

A figure in the midst of an action is usually more appealing than a figure that is reclining; the action results in a more convincing "moment of life." However, it is not easy to convey action in a painting without making it an illustration. I try to avoid rigid drawing lines and careful paint application when painting a figure in motion. Both should depend on the linear content of the painting to portray the action rather than on perfect execution of anatomical detail. The paint should be applied with a light hand. Beware of overworking such a painting. It can easily lose its fluidity, become lifeless, and convey an awkward moment rather than suggest movement.

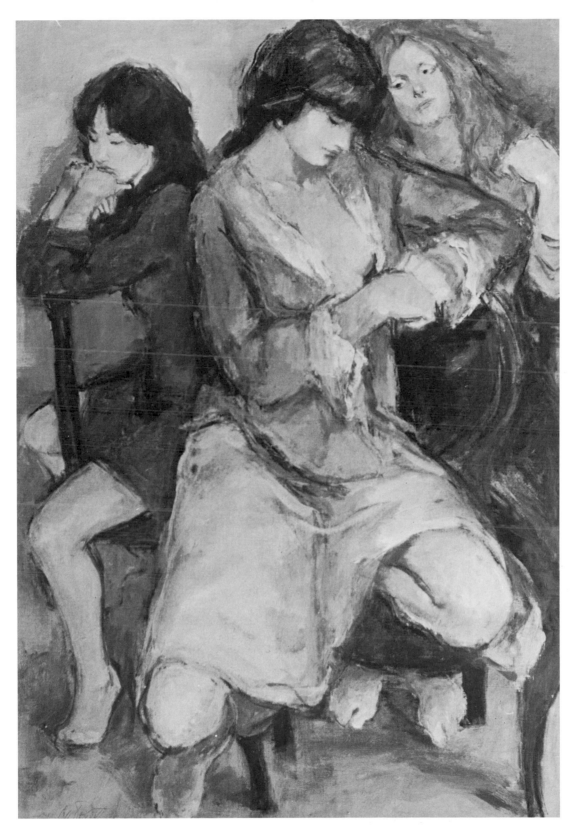

TRIO, 34″ × 24″ (86½ × 61 cm). Collection of Dr. and Mrs. Steven Baum. Courtesy Tyringham Gallery, Tyringham, Mass.

In *Trio*, the figure in front was originally posed as if for a single-figure canvas. One day, however, another model assumed a pose that seemed a perfect contrast to the first one, so I added a second figure. Although the two figures are similarly posed—hands meeting, arms leaning against a chair—the chair of the figure in the foreground has a round back, whereas the chair of the figure in the rear is but a straight line, thus creating a complementary contrast. The figure in back was painted with simpler brushwork, allowing it to recede. I then put the painting away, even though an empty space remained in the upper right corner. This space could have been filled with a simple line, but, as it happened, the right model walked into my studio. I painted her with just a few strokes and subtle colors so that she wouldn't intrude, but only finish the composition.

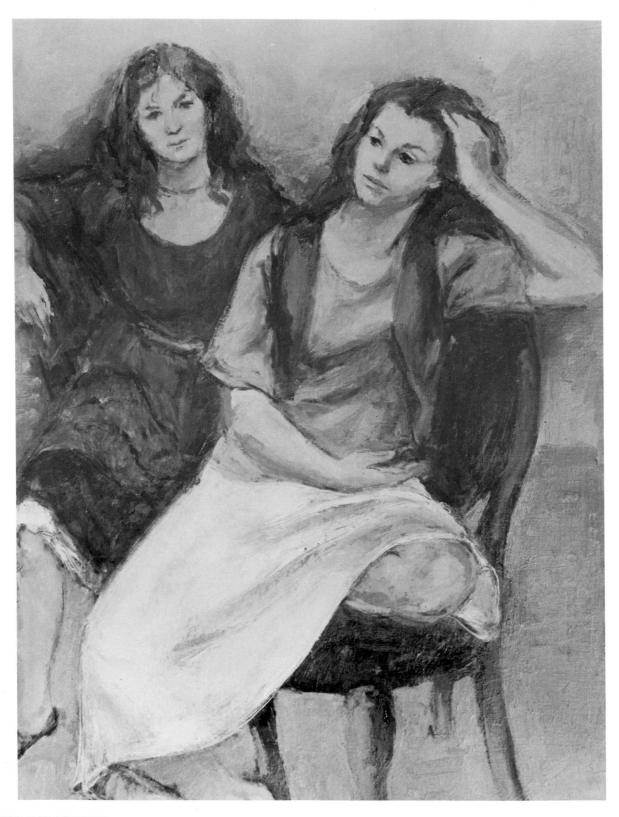

DISTANT SOUNDS, 34″ × 24″ (86½ × 61 cm).
Collection Mr. and Mrs. Daniel J. Wolfson. Courtesy Tyringham Gallery, Tyringham, Mass.

When I started this painting I envisioned it with only one figure. The figure leaning to one side and turning one leg in the opposite direction lends itself to a flowing gesture. The arm upon which the model is resting her head and the knee and chair filled one corner of the canvas, but the rest of the canvas seemed empty. I could have added some lines of drapery or indicated some other object suitable for a background, but these would never have the pictorial strength of another figure. Since the foreground figure has a certain dramatic flow, and because space was limited, I decided on a rather stark and simple pose for the background figure. The figures are united by two aspects of the painting. First, I made a round opening in the second figure's blouse; the half circles produce unity. Second, the figure in front produces a triangle pointing toward the upper part of the canvas, and the arm of the second figure, resting on the chair, produces a triangle that points toward the lower part of the canvas. Both triangles are on one level, creating contrast as well as unity. Did

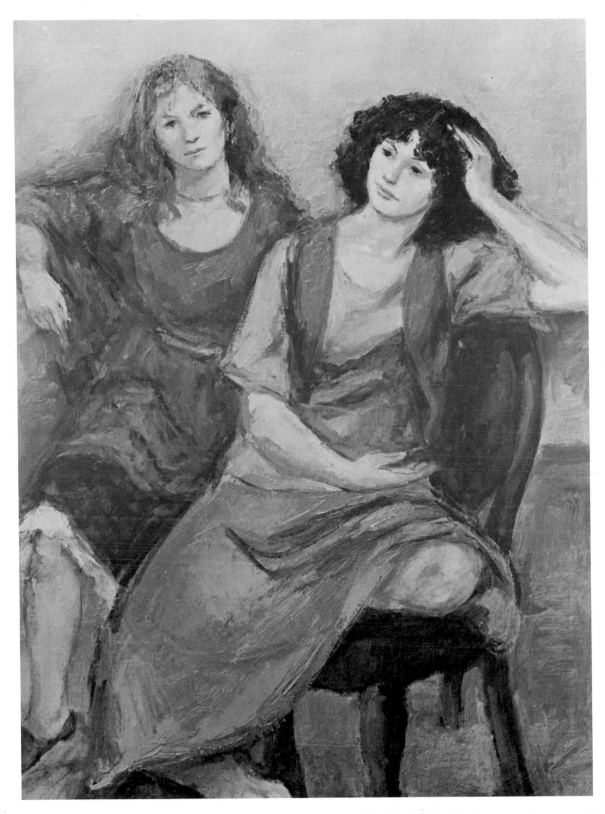

I arrange the model to achieve this result? Of course not, but I did allow her to move from one pose to another until I felt that the figures would be a harmonious unit.

I include these two paintings to illustrate why you should never fall in love with what you have produced. On first reaction, I was satisfied with *Distant Sounds*. As long as I left the painting leaning against the wall, it seemed finished. But once I had hung it on my studio wall, it began to bother me. Although there was nothing wrong with the color or the composition, I had the feeling that something was missing. That feeling grew stronger, and I finally realized that what it lacked was excitement and contrast. The problem was that the heads were too much alike. After scraping and sandpapering the figure in front, I asked my friend Kelly to pose for me so that I could paint her face over the one that I'd erased. As you can see, the result more than justifies the destruction of the first painting. The rule is, never hesitate to scrape, for if it's no good, you can always scrape again.

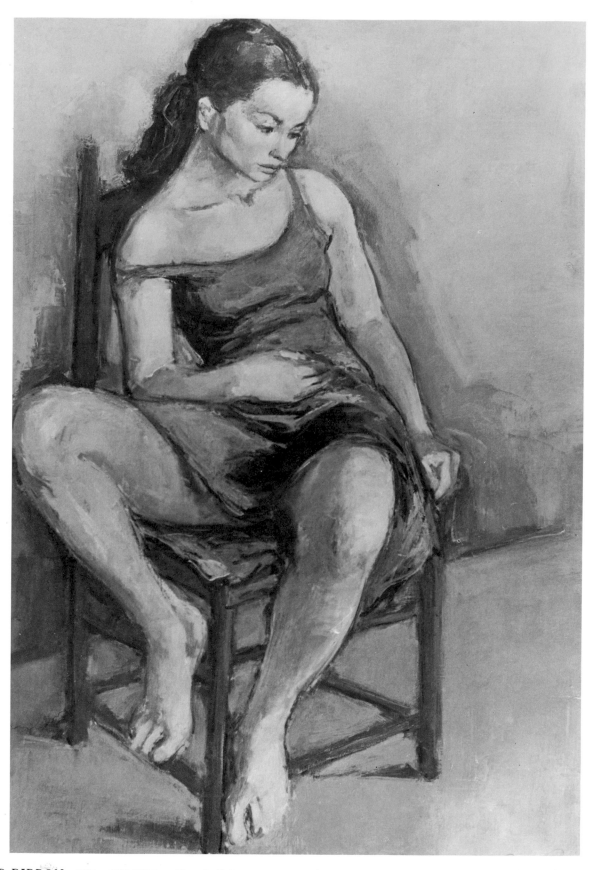

RED RIBBON, 38″ × 28″ (96½ × 71 cm). Private Collection.

I find that adding a new piece of furniture makes for good changes in a composition. In the case of this painting it was a very old chair that I added. You may not be aware of it, but it is the starkness of the chair against the round sensuousness of the figure that produces the mood of the painting. The directions of the figure (the upper part of the body cuts diagonally through the upper half of the canvas, while the legs point in the opposite direction) produce an additional contrast within the square of the canvas. The various color adjustments between figure and chair bring about the needed balance.

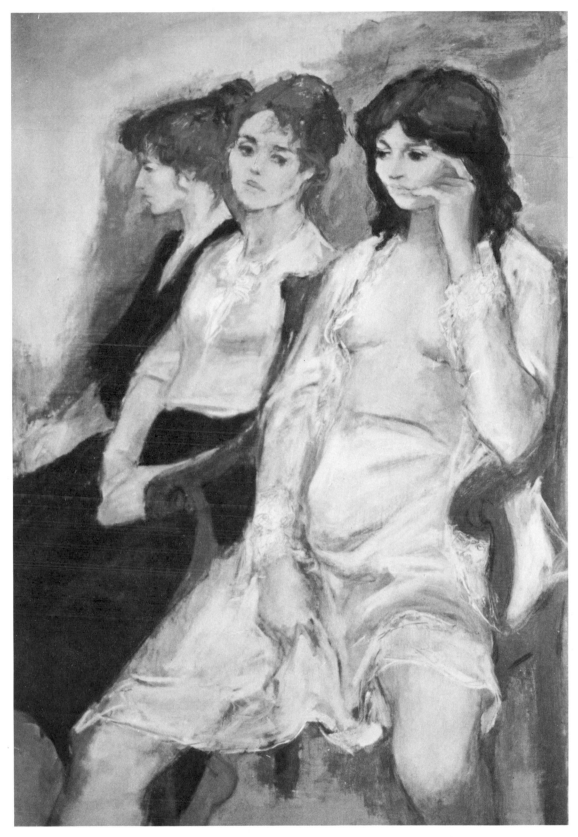

WITHOUT WORDS, 32″ × 22″ (81 × 56 cm).

I began to compose this painting with the figure seated in the visible chair. After I added the second figure, the painting still seemed unsatisfying; cover the most distant figure with your hand and you'll see what I mean. The figures did not relate. With one figure in white and the other in a white blouse and black skirt, I knew that adding a third figure in black would make the best color arrangement of the composition.

The painting was underpainted with oil pastels in shades of red that eventually became black. For the white I used pinks and light yellows. Of course, the black and white tones are really full of subtle variations of color that shine through the final surface.

As I progressed toward the added figure I simplified form and paint application to allow the figure to recede. The background varies from orange to yellow, warm colors that soften the stark colors and gestures of the models.

Part Three:
Demonstrations

DEMONSTRATION 1
ALLA PRIMA PAINTING IN WARM TONES

Alla prima painting is done wet-in-wet and should be finished in one session. The technique forces the artist to eliminate unnecessary details; it is this simplicity that produces aesthetic results.

Alla prima forces a certain virtuosity upon the painter. Although virtuosity is not in itself bad, it can lead to slickness, which is most undesirable. To guard against slickness, use the alla prima method only occasionally, rather than making it an everyday procedure.

Christine, who sat for this painting, and I have long been friends. Hers is a strong face, filled with intelligence, warmth, and female guile. I chose her for this demonstration because I knew I would have no trouble establishing a likeness as I painted by the rules of alla prima.

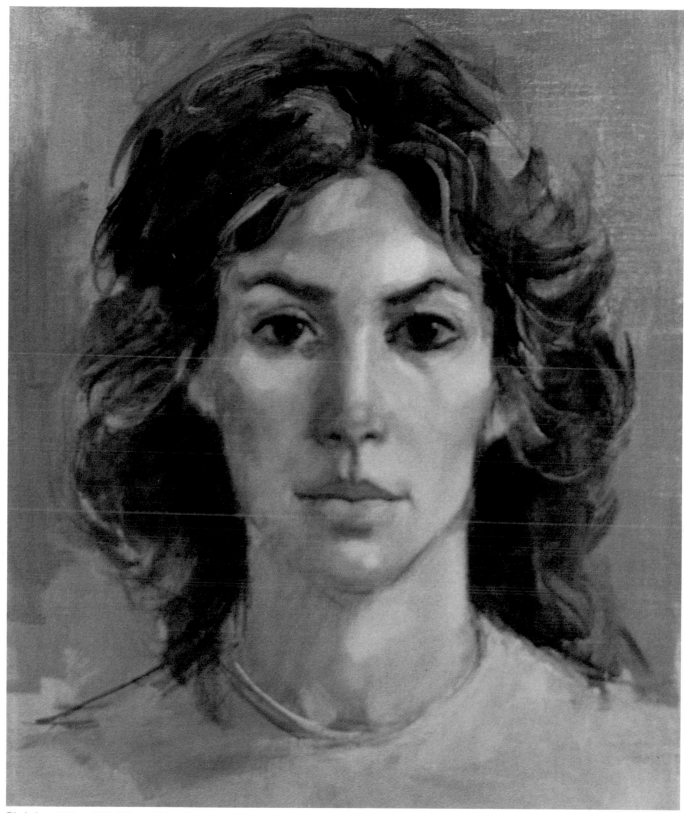

Christine, 22″ × 16″ (56 × 40½ cm).

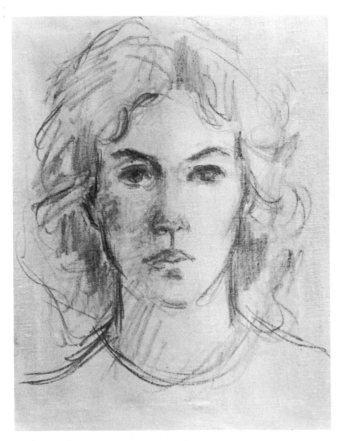 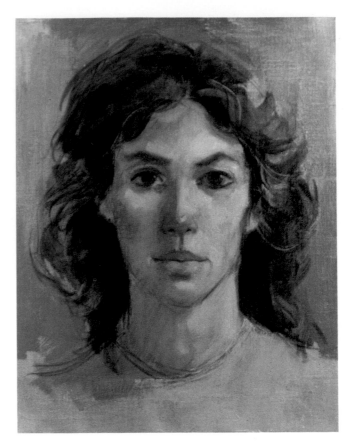

STAGE 1: PREPARING THE CANVAS, DRAWING.
I prepare the canvas for an all prima painting in warm hues in two steps. First, I underpaint the canvas with a mixture of flake white, Venetian red, and raw umber, which produces a color similar to that of very light coffee. Then, after the paint has dried completely, I spread an imprimatura of burnt sienna lightly over the canvas and rub it into the grain of the canvas with the palm of my hand to smooth the surface.

When the canvas is securely dry (after several days), I sketch the drawing with charcoal. In drawing *Christine* I emphasize achieving a likeness of the model. After adding a little more shading with charcoal to complete the drawing, I spray it with fixative. In the finished painting, the charcoal drawing will remain an integral part of the final surface, showing through the warm glazes in the shadow areas and contributing just the right shade of gray.

STAGE 2: I cover the whole canvas with a light imprimatura of burnt sienna mixed with a touch of white, working with painting medium and sable brushes. I mix flake white, ultramarine blue, and raw umber to two shades of gray and surround the head with them using a sable brush and a round painting knife. I scrape away some of the paint I have just applied to allow some of the underpainting to show through. Next, I take some of the gray paint and apply it to the shadow areas of the garment.

I prepare a glaze of burnt sienna and white that is a few shades darker than the underpainting and glaze the shadow areas of the skin with it. I apply a mixture of flake white and yellow ochre to the light areas of the face and neck. The eyes and eyelashes are a mixture of raw umber and raw sienna.

Using a large blending knife, and being careful not to disturb the glazes, I now blend and scrape lightly across the opaque parts of the face, allowing the warm underpainting to play its part. I paint the lips (the upper lip slightly darker) in two shades of Venetian red and blend them into the surrounding skin area. I glaze the hair with burnt umber (Christine's hair has a reddish hue; hence the warmer brown), then reestablish some of the drawing with a scriptliner and burnt sienna.

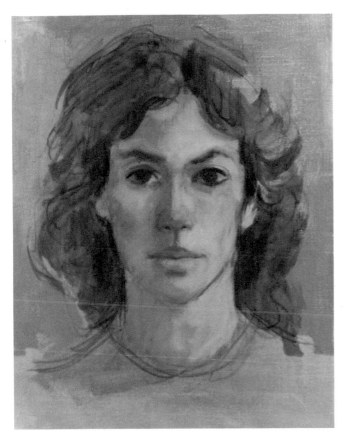
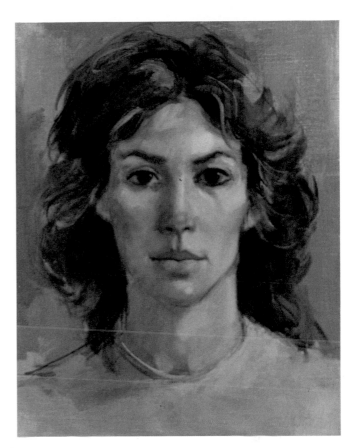

STAGE 3: With a light shade of flake white and yellow ochre, using a bristle brush, I paint in lighter areas, then blend them with the large blending knife. I add some burnt umber to darken the glaze and cover the darker areas of the hair with it. Now, with a piece of cheesecloth, I wipe away some of the glaze to establish areas of light (see page 87 for the exact procedure). I mix flake white with a touch of cadmium red light and apply it to the garment with a painting knife, adding a little more white for the lighter areas; then I scrape and blend.

STAGE 4: FINISHING TOUCHES. On the palette I add more white to the skin color, then apply this paint to the lightest skin areas by scumbling with a pointed painting knife. I blend these scumbles into the surrounding areas with the blender. To the burnt umber glaze I add a mixture of a little yellow ochre and flake white and apply it with a round bristle brush to the very light areas of the hair. These touches consist of nothing more than a dab of paint here and there; I don't concern myself with detail.

With a scriptliner and burnt sienna, I redraw the lines of the drawing. The burnt sienna unifies the painting since it has been used on almost every area of the canvas. As a final touch, I highlight the iris of the eyes with the middle tone of skin color.

Once the model leaves the room the painting must be able to stand on its own, although there is always a temptation to please the sitter or even oneself by achieving a likeness. When painting a portrait a likeness is a must. When working on a "painting," the likeness must be submerged into the total concept. This is especially true of a painting produced with an alla prima method where the fluidity of drawing and the free application of paint are so important to the result.

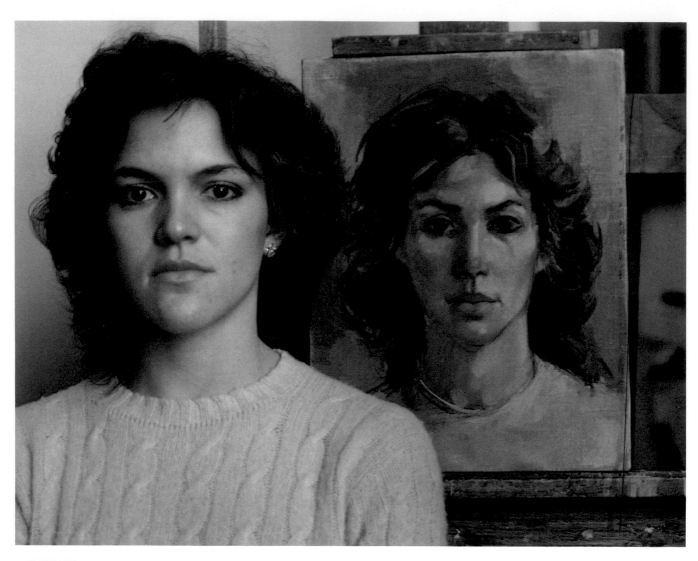

DETAIL. The painting of Christine is a character sketch and not a portrait. Although there is a likeness, this was not the primary intent but rather to translate her features into a new reality on canvas. The painting has a life of its own born of pigment, brush, and knife and the artist's technique and feelings of the moment.

DEMONSTRATION 2
ALLA PRIMA PAINTING IN COOL TONES

The term *alla prima* generally implies that the painting was done—start to finish—in one session. Both *Christine* and *Elisabeth* were painted on the same day, neither requiring more than an hour and a half to complete.

An alla prima painting looks as if the artist has just dashed it off. The casual appearance is deceptive, however, for alla prima demands not only speed but concentration and dexterity. Although you must work rapidly, don't think of yourself as being in a race; no one is timing you. In the end, the painting will be judged by its final effect and not by the amount of time it took to achieve that effect.

To become comfortable with the alla prima method, you must experiment, and perhaps you will fail in your first attempts. Once you master the technique, however, your feelings will flow onto the canvas. It might help to draw your subject several times on paper before attempting to paint. With each drawing you will become a little more familiar with your subject so that when you begin to draw on the canvas your lines will be free of hesitation and filled with conviction.

It is the spontaneity and fluidity of alla prima painting that make it such a highly desirable technique. Its bravura will engage the viewer.

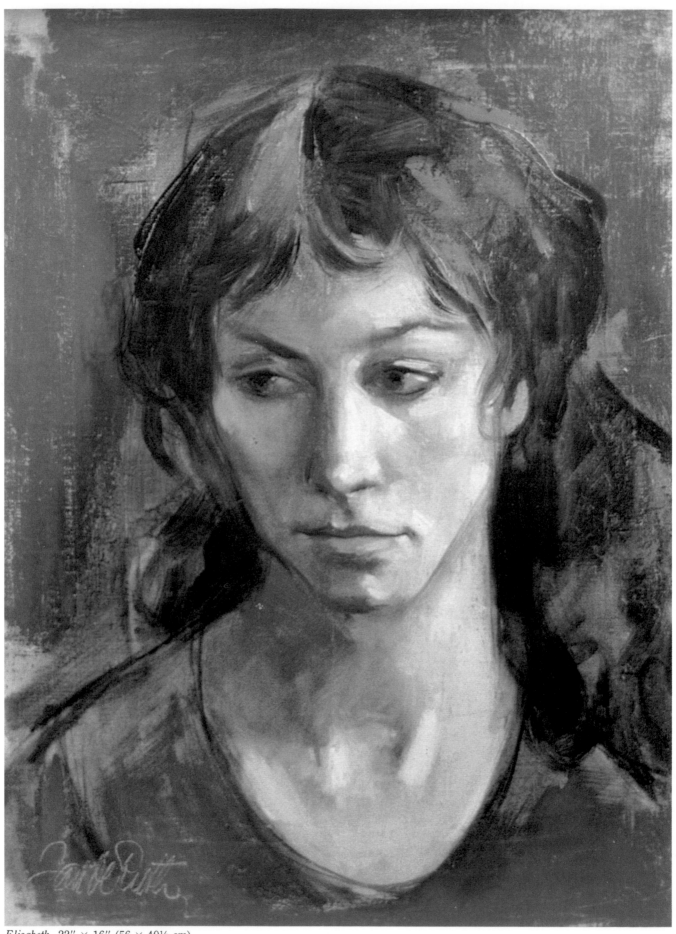

Elisabeth, 22″ × 16″ (56 × 40½ cm).

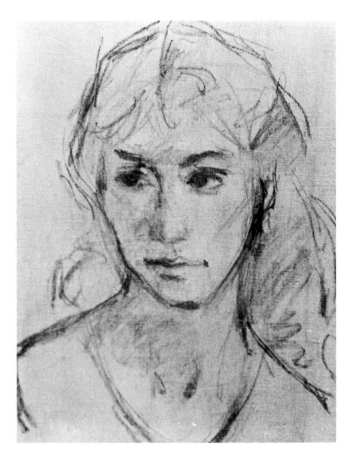

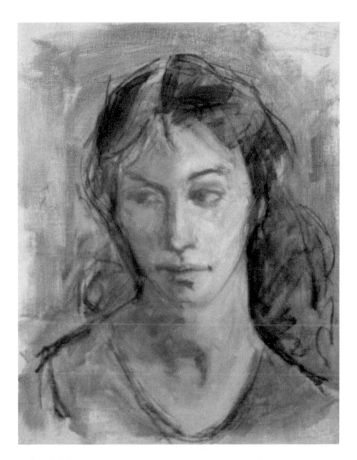

STAGE 1: THE DRAWING. I plan to paint *Elisabeth* in cool tones on a cool surface, consisting of a canvas primed with light blue and washed over with a light glaze of burnt sienna. Such a glaze is called an imprimatura. (Dammar varnish or painting medium can be used for the glaze, and the canvas must first be absolutely dry.) The light blue and burnt sienna will be the middle tone throughout the painting. To begin, I draw the head with charcoal, spray the canvas with fixative, and let it dry.

This is the step in which to establish a likeness if that is what is desired. If the painting is to be a study rather than a portrait, the lines can flow more freely. The charcoal drawing will be an integral part of the finished painting.

STAGE 2: I cover the canvas with a light imprimatura of burnt sienna mixed with a touch of white. This warm imprimatura will pick up the cool tones that I will add later.

I work here with sable brushes. I mix a glaze of yellow ochre, ultramarine blue, and flake white to a blue-green tint. As I glaze the shadow areas, I pick up some of the burnt sienna glaze. I do not move the brush back and forth, but simply pick up the paint from the palette and apply it to the canvas. Moving the paint too much destroys the glaze. I surround the head with a glaze of viridian green, which I apply to the garment as well. I cover the hair with a glaze of raw umber, allowing the background and hair to flow into each other at some points.

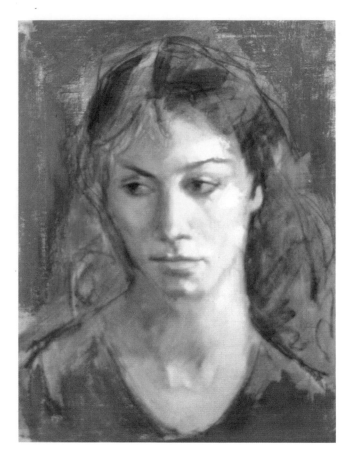

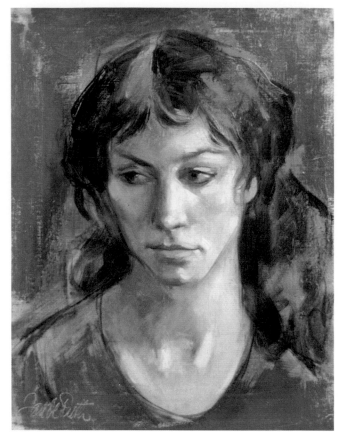

STAGE 3: This step includes the middle hues of the skin. I fill a sable brush with a mixture of yellow ochre and white and apply it to the canvas, then leave it alone. For the iris I mix raw umber with a touch of ultramarine blue; the same pigments are used for the eyelashes and eyebrows. For the lips, I mix Venetian red, a touch of yellow ochre, and white, a darker shade for the upper lip, a lighter one for the lower one. With a small round painting knife, I scumble a mixture of Venetian red, a touch of cadmium red light, and some Naples yellow into the green background and into the garment. I blend and scrape with a large blending knife, allowing some of the initial surface to appear and to soften the hard edges. With a scriptliner and burnt sienna, I redraw some of the head and divide the lips.

STAGE 4: FINISHING TOUCHES. After changing to a bristle brush, I add some white to the skin tone and add it to the light areas. With a pointed painting knife, I add heavy scumbles to the very light areas (see detail). I add a darker glaze of raw umber to the dark areas of the hair. With the painting knife, I scumble a mixture of ultramarine blue, yellow ochre, and a touch of white added to ths raw umber glaze into the light areas of the hair. With the large blending knife, I go lightly over the brush strokes and knife scumbles, blending and scraping lightly so that all paint strata become one. With a scriptliner and burnt sienna, I redraw the head wherever I see the need to enhance or clarify it, but I make sure not to overdo it. I don't trace old lines, but let this be a new drawing.

The finished alla prima painting consists of an interplay of all the applications, from the charcoal lines to the final glaze, each making an appearance in some area of the canvas.

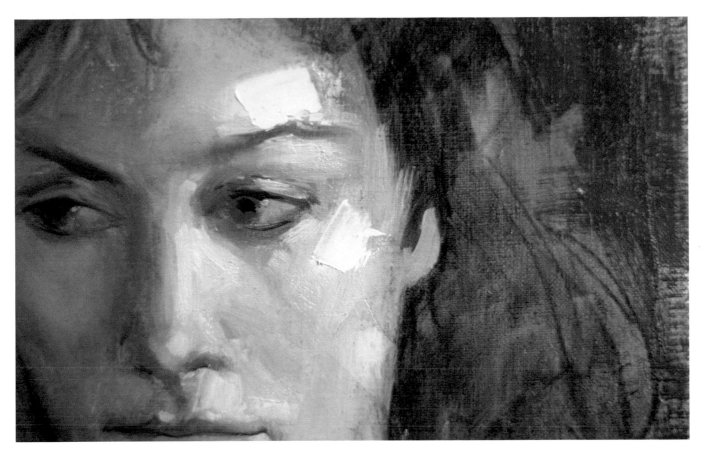

DETAIL. The heavy scumbles on the skin may look as if they were haphazardly applied, but they weren't. Experience has taught me precisely how much paint to transfer from the palette to the canvas. Once a scumble has been put in place, it should remain untouched except for smoothing and blending the edges into the surrounding areas. Scumbles add greatly to the three-dimensional effect of a painting.

DEMONSTRATION 3

MONOCHROME UNDERPAINTING OF SKIN IN WARM TONES
OVERPAINTING OF SKIN IN COOL TONES
UNDERPAINTING OF GARMENTS IN COOL TONES
OVERPAINTING OF GARMENTS IN WARM TONES

Whether working with oil pastels, alkyds, or other materials that may make the process of painting simpler, yet add interest, there's still no substitute for the old process of underpainting with oils and finishing the painting in a classical manner. You will find the warm underpaintings of skin tones as in *Red Skirt* among the works of Goya and Velazquez.

I implore you not to forego this time-tested method. You must first truly master it, for it is from this classical method that the others described in this book are derived. Don't look for the easy road; it just isn't there. Once you have mastered the underpainting, glazing, and scumbling with brush and knife of oil paints, as they have been used for centuries, you can learn the easier method.

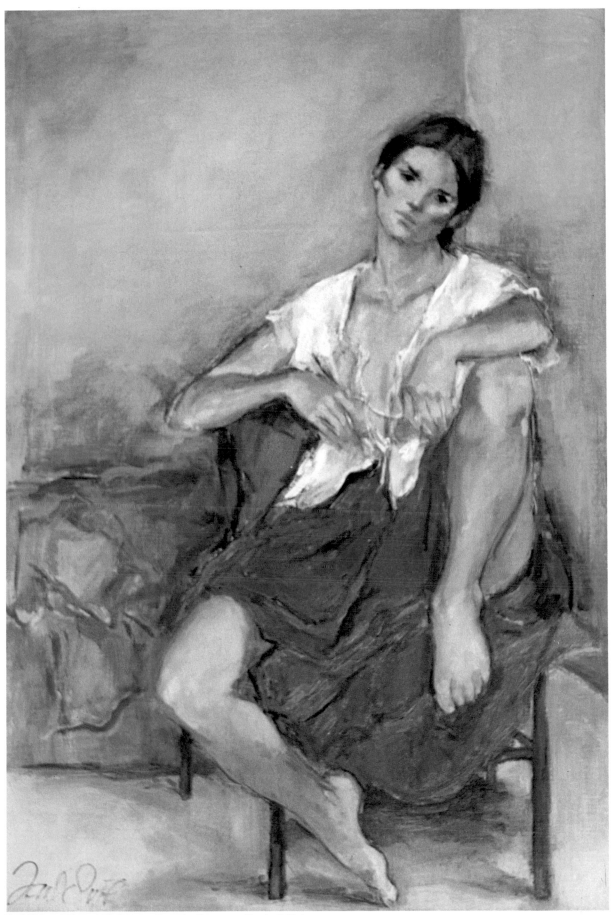

Red Skirt, 36″ × 24″ (9½ × 61 cm). Courtesy Stark & Raines
Gallery, Palm Beach, Florida.

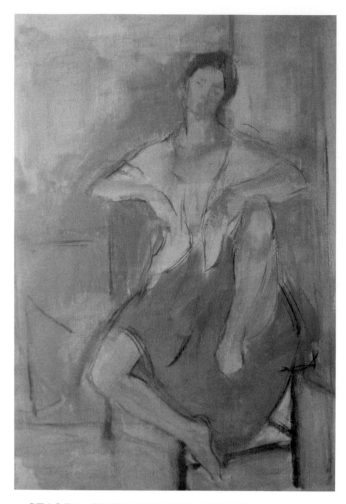

STAGE 1: THE DRAWING. Because there will be a full underpainting of regular oils, the drawing will be completely covered by the various paint applications. The purpose of the drawing is to place the figure and determine its flow within the canvas. I make the drawing on a white canvas, using a medium-soft charcoal stick. Before drawing, I make sure that what I'm about to draw is clearly formed in my mind and spirit, so that I'll need to correct or alter it as little as possible. Once the image takes shape on the canvas, I adjust a line or form to fit the symmetry that is beginning its new life on the canvas. The drawing completed, I spray it with fixative and leave it to dry.

STAGE 2: FIRST UNDERPAINTING. I do the underpainting with the short painting knife, using no medium. I mix flake white, Venetian red, and a touch of raw umber (to facilitate drying) to a light pink, which will cover the shadow areas of the skin and the darker areas of the background. I then add more flake white to obtain a lighter pink, with which I cover the lighter areas of skin and background. The blouse is flake white and Naples yellow; to the same mixture I add a touch of cadmium red light for the pillow against which the figure is leaning. The skirt consists of flake white, Prussian blue, and raw sienna. I add some more white for the background drape. The hair is underpainted with the same tone as the skirt. I apply the paint freely, with consideration for lights and darks only. The whole canvas is covered in a monochrome tone. Using the large blending knife, I blend the figure into the background, and vice versa, with flat, horizontal strokes, always from light into dark. The blending is done lightly to achieve a smooth surface and eliminate sharp edges. The knife must be cleaned constantly. When the blending is done, I redraw the figure with a scriptliner, using burnt sienna and turpentine. With a large flat sable brush, I blend the figure, background, and drawing, barely touching the canvas, with long horizontal strokes. The brush must be cleaned constantly so that it doesn't drag paint from one area to another. I put the canvas away to dry.

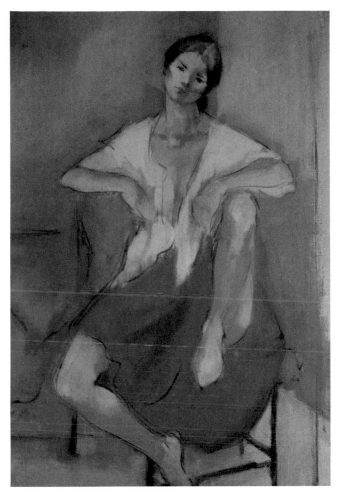

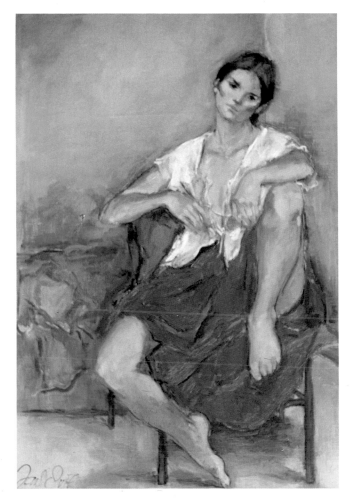

STAGE 3: SECOND UNDERPAINTING. The painting must be completely dry before the application of the second paint stratum. I erase any imperfections of the surface with fine sandpaper, using horizontal strokes. I then wash over the whole canvas with a thin film of turpentine. Once it has evaporated, I spread a thin film of medium across the surface and rub it into the first underpainting with the palm of my hand. This allows the paint to flow more easily and helps the adhesion of the second layer of pigment.

During the first underpainting, the primary task was to establish areas of darks and lights. During the second underpainting, I shall concern myself with creating form by means of darks and lights. All applications that require some precision are done with bristle brushes; larger areas are covered with the painting knife. I use no medium; the medium on the canvas should suffice.

Once again, I mix two shades of pink, but now I add a third, even lighter shade—almost white—to form the various skin tones. I add more Prussian blue to the green mixture for the dark areas of the hair and the skirt. I still work from light to dark, adding form and depth. Once the whole canvas has been painted and the figure refined, I blend this new paint stratum, using the painting knife, within the figure and with the background. With burnt sienna, turpentine, and a scriptliner, I redraw the figure, trying not to follow earlier lines but letting the line flow freely along the forms that develop. I then blend the whole surface with a large sable brush and put the canvas away to dry.

STAGE 4: OVERPAINTING, GLAZING, AND SCUMBLING. After the painting is dry and I have smoothed imperfections with sandpaper, I cover the canvas with a thin film of turpentine and allow it to evaporate. Then I rub a light film of painting medium into the surface.

I surround the figure with a glaze of Prussian blue, raw umber, and white; this allows me to blend the figure and background at any time. I apply the glazes on the skin areas with sable brushes. The mixture for the shadow glaze is ultramarine blue, yellow ochre, and white; the middle tones are flake white and yellow ochre, with some more white for the lighter areas. This is applied with a bristle brush. I use a glaze of raw umber for the hair, eyes, and eyebrows. For the lips I add a touch of burnt sienna to the middle skin tones. I blend glazes and impastos lightly with the blending knife, allowing some of the pink underpainting to show through.

The skirt and background drape are glazed with viridian green. Into that shade, using a bristle brush, I scumble a mixture of cadmium red light and alizarin crimson, which produces a vermilion red. I then scrape some of it away, so that the green underpainting appears and lends a richer quality to the red. To a little of this red I add Mars violet and white, which I brush into the background drape. The pillow behind the figure is Mars yellow and a touch of white. I add a corner of the pillow on the side opposite the figure for color balance. I scrape some of the paint so that the underpainting will add some richness to the color. I mix several shades of a grayish blue and apply them with a painting knife to the background and floor. I glaze the blouse with cerulean blue and white. Into this, using a bristle brush then the small painting knife, I scumble white with a touch of Naples yellow. The chair is white, cerulean blue, and raw umber.

Finally, I reestablish some of the drawing with a scriptliner and burnt sienna and allow the canvas to dry.

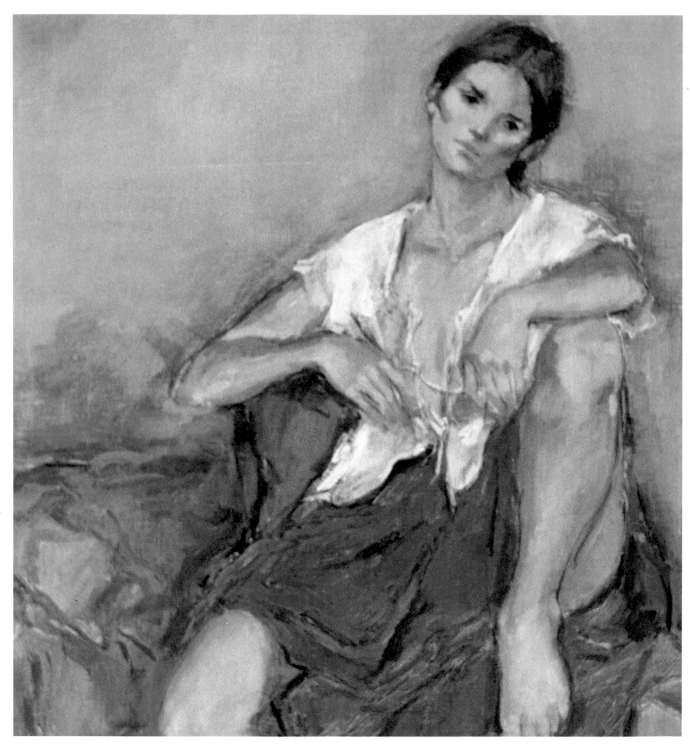

STAGE 5: FINISHING TOUCHES. Again I prepare the canvas by spreading a thin film of turpentine and then a thin film of medium across the surface. The canvas now needs only to be enhanced—a touch of light here, an additional glaze there, a reflection of the background color added to the hair. Perhaps the red of the skirt can be made even livelier by some touches of cadmium red light. Using a round bristle brush, I add viridian green glazes within the skirt, ignoring folds as they may exist in life but adding those that will strengthen the shape and color of the skirt. I also surround some parts of the figure with the same glaze in various strengths, adding to the three-dimensional quality of the figure. I produce the shadows underneath the chair in the same manner.

I doubt that there are many painters who can finish an overpainting as described in this demonstration in one, two, or three sittings, but you certainly should attempt it in two; beyond that you don't need the model. In fact, the model may hold you too much within the realities of life.

I omitted something throughout this demonstration, but I did so on purpose, for I also omitted it while painting: the blue ribbonlike band on the model's skirt. Such things I always leave for the end. To incorporate such a detail in the early stages would eliminate the free flow of brushwork. It might also be distracting to the overall composition. But once the painting is near completion, I can always decide if such an addition is necessary. To add it, I used cerulean blue with a touch of cobalt blue and white, following the lines of the composition within the figure. Of course, I ignored the true pattern and made it an accent to the new life of the painting.

DEMONSTRATION 4

UNDERPAINTING OF SKIN IN COOL TONES
OVERPAINTING OF SKIN IN WARM TONES
UNDERPAINTING OF GARMENTS IN WARM TONES
OVERPAINTING OF GARMENTS IN COOL TONES

The method used to paint *Isabel's White Slip* is derived from the under- and overpainting techniques used by such masters as Rubens, Titian, Rembrandt, Boucher, Ingres, Degas, and many others. It consists of underpainting the canvas with knife and brush in cool tones and overpainting with the colors of a full palette.

The underpainting is done in chiaroscuro or monochrome (variations of a single color), allowing me to establish lights and darks without mixing different hues. Such a monochrome could be light gray, light blue, or light green. In painting skin, the gradation must be subtle, for the underpainting will become part of the final surface. By applying the paint in stages, I also work from lean to fat, which will help the durability of the painting.

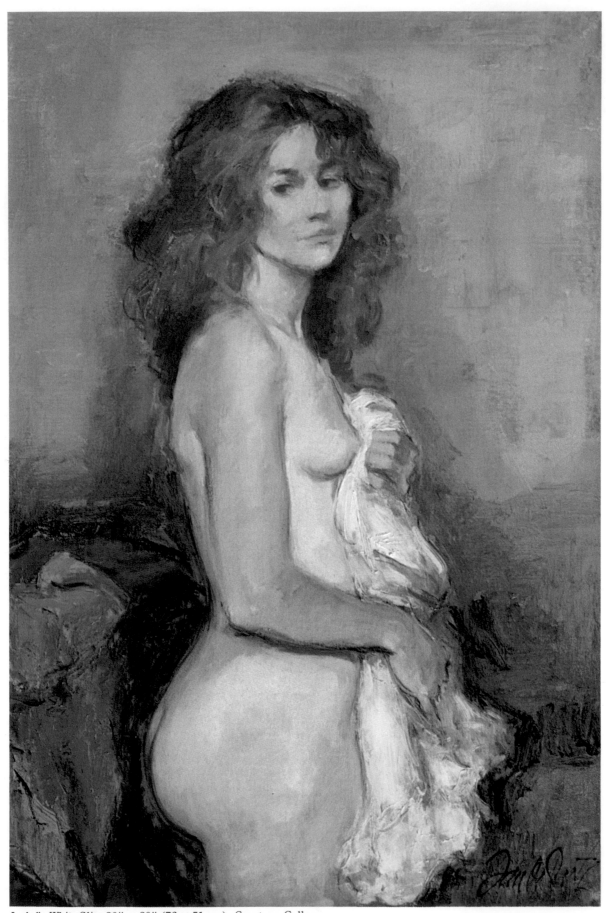

Isabel's White Slip, 30″ × 20″ (76 × 51 cm). Courtesy Gallery
Beatrice Zarges, Munich, West Germany.

STAGE 1: THE DRAWING. I prime the canvas with a grayish-blue ground, a mixture of Prussian blue, raw umber, and flake white. After the priming is completely dry, I sandpaper the priming to eliminate any roughness that may remain from applying the paint with a painting knife. The drawing is done with a round sable brush, using raw umber and turpentine. Raw umber is a color that is easily absorbed by the cool underpainting without changing its tint.

There is no technical reason for drawing with charcoal on one occasion and with a brush on another. It may be the mood of the day, the model's character, or just change for the sake of change.

STAGE 2: FIRST UNDERPAINTING. The pigment of the underpainting is applied with a round painting knife. The light blue is a mixture of Prussian blue and flake white combined with some raw umber to facilitate drying. I prepare three shades of the blue, all of them light but of three gradations. I apply the paint with the short painting knife, working from dark to light on all skin areas. I am not concerned with detail, but only with how the darks and lights contribute to the form. I use the darkest tone to surround the figure and the medium tone for some of the background. The mixture for the hair is yellow ochre and white. I underpaint the areas of the background that will later appear cool in a pink consisting of Venetian red, raw umber, and white. For the slip, I add some white to that mixture.

After covering the whole canvas with paint, I use the blending knife to smooth and blend the paint within the figure, then, moving lightly from the edge of the figure, blend it into the background and vice versa. I do the same with the hair and the slip, and I blend the different hues of the background so that their edges flow into one another. Then, with a number 3 scriptliner and burnt sienna diluted with turpentine, I reestablish the drawing. I use a large flat sable brush and move lightly across the whole canvas in horizontal lines, wiping the brush constantly so that I do not drag paint from one hue to another. This adds texture and evens out any imperfections left by the blending knife. Then I allow the canvas to dry completely.

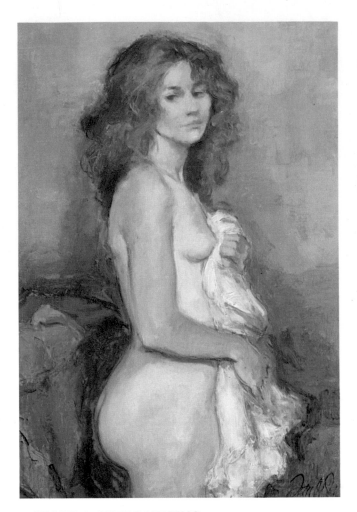

STAGE 3: SECOND UNDERPAINTING. I examine the painting for possible imperfections and erase them with light horizontal strokes of fine sandpaper. I wipe off the dust and spread a thin film of turpentine on the canvas. After allowing it to evaporate, I spread a thin film of painting medium across the canvas and rub it in with the palm of my hand. I change from light blue to a light green tone for the underpainting. This will add one more dimension to the richness of the eventual paint surface. I paint with a minimum of medium; there is just enough on the canvas for an easy flow of the brush.

To obtain the green hue I mix flake white, yellow ochre, a little Prussian blue, and some raw umber. At this stage I apply the paint with bristle brushes. Again I mix three shades and start by applying the darkest shade, then follow through to the lightest shade.

Now I begin to be concerned with a more specific rendition. I apply the brush with the desired color to the canvas, then remove it. I don't try to mold the shape like a sculptor, but produce it through darks and lights. There are now two shades for the hair, with a little raw umber added for the darker parts. The most expedient way to apply the background is with the knife. I allow some of the blue to remain visible. The mixture for the slip is flake white and Naples yellow. I add some stronger hues to the background draperies, giving them more form.

Again, I blend within the figure and the figure with the background. I reestablish the drawing, finding new forms and shapes; I don't repeat myself but improve on what I already have. I blend the whole canvas with a flat sable brush, using horizontal strokes. I keep the brush clean; this is important because I will want to do as little correcting as possible when I start mixing colors for the overpainting. Finally, I allow the canvas to dry completely.

STAGE 4: OVERPAINTING. After erasing any imperfections with sandpaper, I spread a thin film of turpentine over the canvas. After it has evaporated, I spread a thin film of painting medium and rub it into the canvas with my hand.

Using a sable brush, I surround the figure with a mixture of Prussian blue, raw umber, and white. I prepare a warm gray glaze by mixing cadmium red light, ultramarine blue, and yellow ochre, with a touch of white, and apply it with a sable brush to the shadow areas of the skin. Then I mix flake white, yellow ochre, and a speck of cadmium red light to three shades, one almost white for the very lightest areas, and apply these mixtures over the middle to light tones of the skin. I scrape lightly over this application to lift some of it and allow for the underpainting to come to the surface. The eyes are painted with a mixture of ultramarine blue, raw umber, and white, using a sable brush. The lips are painted with cadmium red light, a touch of yellow ochre, and white. I glaze the slip with a mixture of cerulean blue, raw umber, and white. Using the pointed painting knife, I scumble white into the slip, picking up some parts of the glaze and leaving others untouched. I glaze the hair with cerulean blue, adding burnt umber for the dark areas. I use some of this tone for the eyebrows, using a sable brush. With round bristle brushes, I scumble a mixture of yellow ochre and white into the hair, but without moving the brush about.

I glaze the background with Prussian blue. With flake white, Mars yellow, a touch of cadmium red light, and black, I obtain three shades of gray, which I apply with the round painting knife to the background, from dark to light. I scrape so that the underpainting shows. I glaze the draperies with viridian green. With a large sable brush, I scumble cadmium red light with Naples yellow into this. The blue is cerulean blue mixed with cobalt blue and a little white. I reestablish some of the form with a scriptliner, using burnt sienna, and allow the canvas to dry.

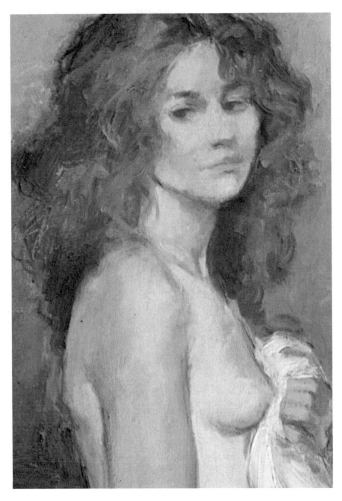

STAGE 5: FINISHING TOUCHES. The canvas must be dry before I continue. As the paint dries, it sinks in and loses some of its luster. I make sure the canvas is free of dust, then spread a thin film of turpentine and allow it to dry. Then I spread a thin film of medium over the whole surface and rub it into the canvas with the palm of my hand.

Now I can add some touches to give more life to the painting. Using a round bristle brush, with cobalt blue and phthalo green, I add some contrasting lines around the figure and accent some of the drapery. I add a touch of pink to divide the right side of the canvas slightly. I also add some cerulean blue and white, some cadmium red light, and Naples yellow to lighten some parts of the drapery, as they need some touches of a lighter shade. Having strengthened the surrounding areas, I mix a hue just a shade lighter than the lightest skin tone and apply it with a flat sable brush to the lightest skin areas, blending them with the surrounding areas.

DETAIL. As you can see here, the paint is quite heavy in some areas, yet the first underpainting is still visible in others. Both the cool underpainting and the warm overpainting play their part.

DEMONSTRATION 5
UNDERPAINTING IN COOL MONOCHROME
OVERPAINTING WITH GLAZES

By present-day social standards, the title of this demonstration should be be "Painting Black Skin," but we are dealing with painting and not with labels. The fact is that there is no such thing as black skin. There are various shades of dark skin, from the sun-tan of a Caucasian to the deep brown of the African. These are merely gradations of skin tone for which the painting procedure varies only slightly and only in the finishing stages.

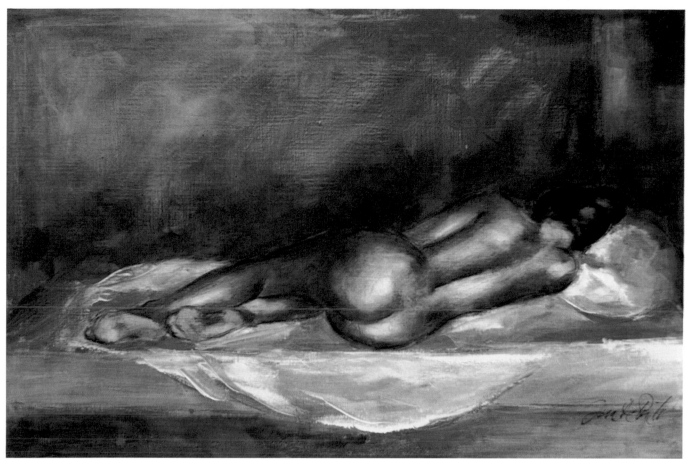

Dreams, 20″ × 30″ (51 × 76 cm). Courtesy Provincetown Art
Gallery, Forest Hills, N.Y.

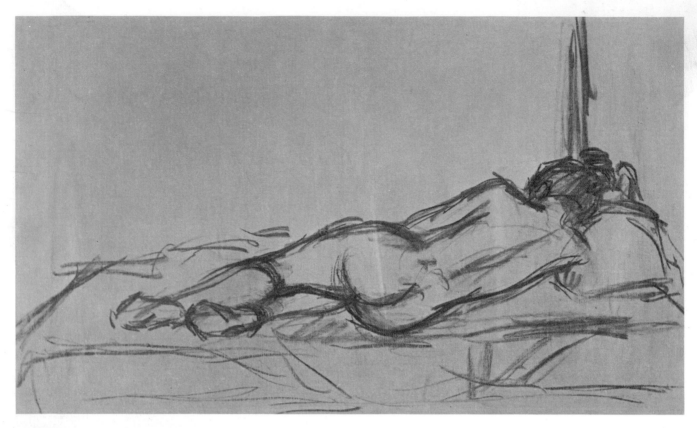

STAGE 1: THE DRAWING. I start with a canvas that
has been primed with a light blue and draw the figure with
charcoal. When I am satisfied with it, I spray the drawing with
fixative and let it dry.

Note that I say *satisfied*; there is no need for perfection. As I
progress with the underpainting, I can correct it without being
plagued by changing colors. Because I am working in
monochrome, I can perpetually redraw, apply paint, and keep
line and form in such a subtle color arrangement that allows me
to make corrections easily.

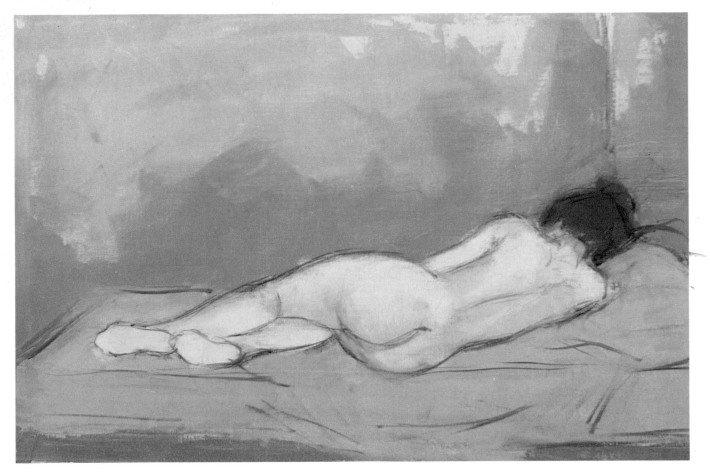

STAGE 2: THE UNDERPAINTING. I mix flake white with chromium oxide green and a touch of raw umber to achieve a green somewhere in the middle—not too light but lighter than chromium oxide green. I surround the figure in the background area with this mixture, applying it with a painting knife.

I mix flake white with a speck of Venetian red and a touch of raw umber to a light pink. Using the painting knife, I spread this mixture on the area upon which the figure is resting.

Now I work on the figure itself. I mix flake white with a touch of Prussian blue to make two shades of *light* blue. Using the darker of the light blues, I paint the shadow areas with a painting knife, then apply the lighter shade of blue to the light areas. For the hair I mix flake white with Prussian blue to a rather dark shade.

With the blending knife I blend the figure into the background and the background into the figure with soft strokes. I blend all areas within the figure so that I obtain a smooth surface that shows none of the texture of the paint application.

Now I return to the background and blend all the areas I have just painted with the soft blending knife. I don't want any texture whatsoever in these early stages, for eventually I'll want to glaze.

Now, using a number 3 scriptliner and burnt sienna, I reestablish the drawing. With a soft number 24 sable brush and with even horizontal strokes, I move lightly over the canvas, keeping the brush clean so that I don't drag paint from one color into another.

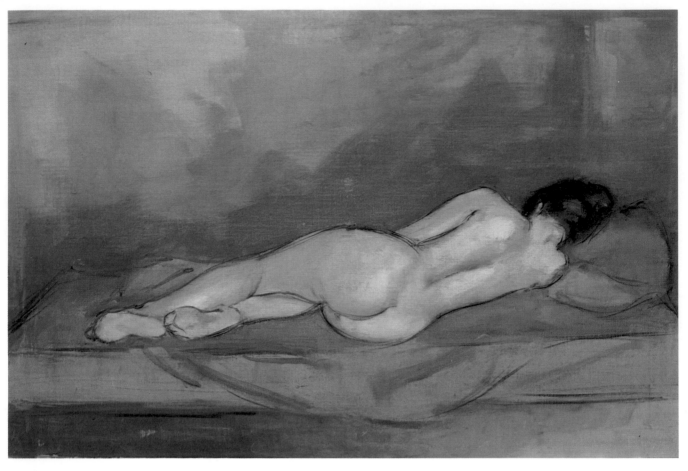

STAGE 3: SECOND UNDERPAINTING. When the canvas is completely dry, I erase any imperfections of the surface with fine sandpaper—lightly, without destroying the texture created through blending with the sable brush. After wiping the canvas clean, I apply a thin film of turpentine. When that has evaporated, I apply a thin film of painting medium and rub it into the canvas with the palm of my hand.

When applying the next stratum of pigment, I don't use any medium; the turpentine already on the canvas suffices as a vehicle of adhesion. I work with bristle brushes.

The essence of the second underpainting is to refine the first one. I add some more form, more light and shade. By strengthening the lights and darks, I may not need to add detail, because the picture will take on its own reality.

I mix flake white with chromium oxide and a touch of Prussian blue to make three different shades, which I apply to the background. I make a light pink by mixing flake white, Venetian red, and a touch of raw umber and apply this to the foreground in two shades, the darker one in the lower left corner, the lighter one toward the lower right. Notice that this creates a diagonal

through the canvas. It is an invisible line, but it subtly enhances the composition.

Now I turn to the figure. I mix three shades of flake white and Prussian blue, the lightest of the three being almost white. I don't go back and forth on the canvas or try to "mold" or sculpt the form. I fill the brush with paint, apply it, and leave the paint alone.

The mixture for the hair is chromium oxide, Prussian blue, and a little raw umber. I make two shades, the lighter one for the light reflections on the hair.

I use the blending knife to blend the figure into the background and the background into the figure. Then I blend the foreground into the figure and vice versa. Some areas from the first underpainting are now visible, but I let them become part of the whole surface; they add interest to the texture.

After blending all areas (being sure to keep the knife clean by wiping it after every use), I take a number 3 scriptliner and burnt sienna and, with painting medium, redraw the figure. I blend all paint applications with a large flat sable brush, using a horizontal stroke. Then I let the canvas dry completely.

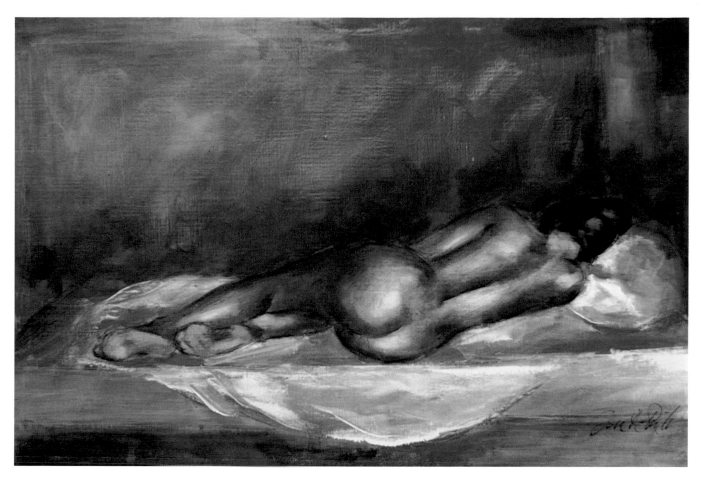

STAGE 4: THE OVERPAINTING. The canvas is now completely dry. To make sure that there are no imperfections in the texture, I take very fine sandpaper and go lightly over any areas that may have escaped the blending knife. I then apply a wash of turpentine over the whole canvas. This washes off any fatty residue that may have risen to the surface. After allowing the turpentine to evaporate, I wipe the canvas with a clean rag, then apply painting medium in a very thin layer to the whole canvas and rub it into the surface with the palm of my hand.

This is probably the easiest and most surprising stage of painting nonwhite skin. I mix a glaze of raw umber, spread it evenly over the whole figure, and allow it to set. While this glaze is setting, I mix viridian green with painting medium into another glaze, which I apply to the background. The underpainting supplies the lights and darks.

I mix raw umber and Naples yellow with a touch of white and, using a sable brush, glaze with this semi-opaque color in the dark areas of the foreground.

I mix Venetian red with touches of yellow ochre and white. Using the painting knife, I apply this mixture evenly around the figure and on all other areas of the background. I don't destroy the glaze—or the green underpainting. Using the blending knife, I scrape the background. I want to see a lot of red but much of the green as well. This will produce a truly rich but subtle red tone.

I wind a soft cloth around my finger, making sure that it is smooth. I look for the light areas on the model, then, with a fast, soft stroke, wipe a little of the glaze away so that the light blue shines through. I change the spot on the cloth before each use. This step should not be overdone. Two or three dabs may do the trick. Overdoing it would destroy the essence of the procedure, which is simplicity. With the painting knife I apply a *light* mixture of Naples yellow and flake white to the foreground. I use the blending knife to scrape and blend the foreground so that some of the pink shows through. Then I mix a glaze of ultramarine blue and raw umber to a dark hue and apply it to the hair.

I mix raw umber with medium, and using a number 3 scriptliner, I redraw the figure ever so lightly. When I finish, I set the painting aside, perhaps laying it down flat so that the glaze won't run. The canvas has to be absolutely dry before I can work on it again.

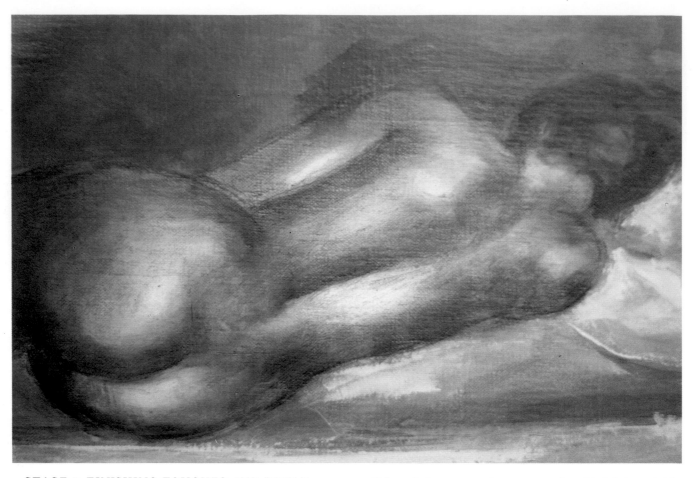

STAGE 5: FINISHING TOUCHES AND DETAIL.

When the painting is completely dry, I use a large sable brush to wash it with turpentine to eliminate any excess oil. I let it evaporate, then apply a thin stratum of painting medium and rub it into the canvas.

This could already be a finished painting, so whatever additions I make must be subtle and well thought out. Some areas on the figure may need darkening. To do this, I mix a glaze of raw umber with some burnt umber and, using a sable brush, glaze over the previous glaze. If I lose the blue in some areas, it doesn't matter. I don't go over the light areas that I wiped with the cloth.

I surround the figure in the background with a glaze of viridian green and add some of this green to the upper right-hand corner. I mix a glaze of cadmium red light—it should be thin so that it's barely visible on the canvas—and cover the whole foreground with it. Then I mix Naples yellow and white and work it into the glaze in the light areas with the painting knife. The right-hand corner becomes very light; the left one should remain dark. The four corners oppose each other in shades of light and dark, creating harmony and drama. The areas in the foreground should be heavily scumbled. I go lightly over the hair with a black glaze.

If the painting now needs an accent of any kind, it is probably another drawing line on the figure here and there where the last layer of paint touches the figure. With a number 3 scriptliner, I reestablish the drawing lines with a mixture of raw umber and burnt umber, and the painting is finished.

Well, no painting is really ever finished. I put it away and have another look a few weeks later. I can then add darks or lights, or a line, but perhaps there will be no need. The painting has assumed its own reality. With the model gone, I can shape and change the painting to please myself and entice the viewer.

The detail above is a perfect example of what a marvelous surface glazes produce. The overpainting on this figure consists literally of nothing but glazes. Once the underpainting of the skin has established the values of light and dark, the glazes add richness of color and texture to its surface. It is such a simple procedure, yet so rewarding in its results. The hair, too, consists of only underpainting and glaze. The scumbles on the drapery and pillow contrast with the smoothness of the skin, giving it luster. Underpainting and glazes produce a rich surface, but the glazes should be applied with discretion. In painting nonwhite skin, glazes are the most important aspect of the surface.

DEMONSTRATION 6

UNDERPAINTING OF SKIN TONES WITH COOL ALKYDS
OVERPAINTING OF SKIN TONES WITH WARM ALKYDS AND OILS
UNDERPAINTING OF GARMENTS WITH OIL PASTELS
OVERPAINTING OF GARMENTS WITH ALKYDS
FINISHING TOUCHES WITH OILS

The possible ways of bringing interest to a man's portrait are limited. His attire is generally conservative. What can one do with a gray, brown, or black suit? In this demonstration, I underpainted the skin tones with alkyds in cool shades. For the garments I used oil pastels of a warm hue to contrast with the blues and grays that would follow during the overpainting. It was my hope to bring a new texture to the painting of the cloth. The oil pastels were intended to remain visible through the various glazes, adding variety to the final surface of trousers, vest, and jacket.

It is always good to finish a portrait in a short period of time, for then one can more easily retain a concept of the sitter. For this the alkyds are most useful. They require a certain care in their application, but that will help you to establish a likeness—which, after all, is the primary purpose of a portrait. When working with alkyds, be sure to use a second palette so that your regular one remains free of the rapidly accumulating alkyd residue.

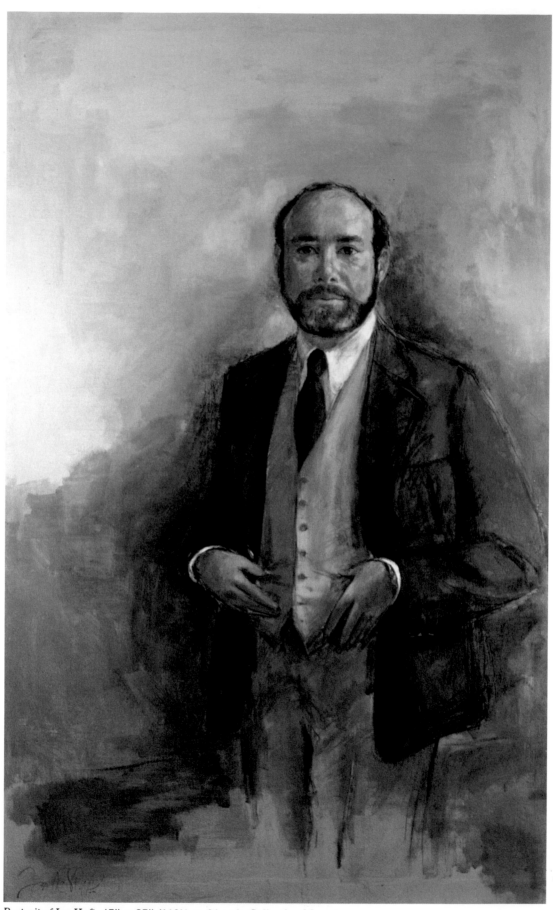

Portrait of Jay Haft, 47″ × 37″ (119½ × 94 cm). Collection Mr.
Jay Haft. Courtesty Portraits, Inc., New York City.

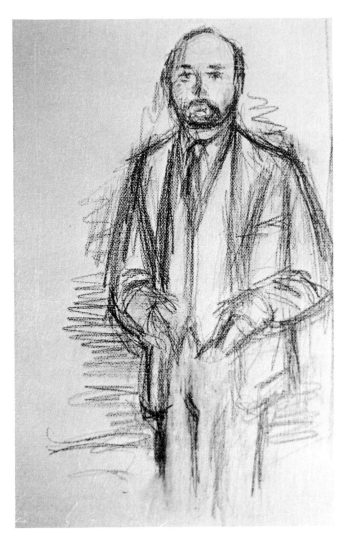

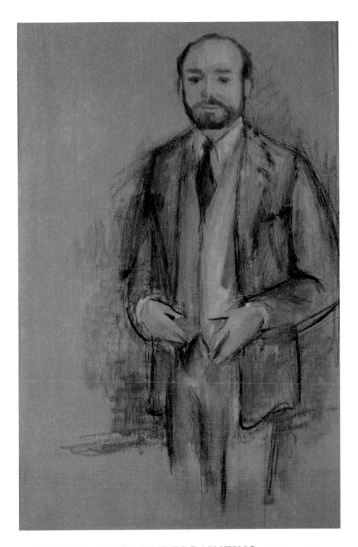

STAGE 1: THE DRAWING. Jay Haft and I have been friends for a long time. I am often asked if it helps to know someone well when painting a portrait, and I would say that it definitely does. Jay had wanted me to paint his portrait for a long time. I put it off, or rather politely sidestepped his hints. Nevertheless, all the time I was observing him with the idea of doing the portrait someday. As a result of this subconscious preparation, the painting literally finished itself without my ever having to correct a line.

I use charcoal for the drawing. Notice that I don't draw the legs all the way to the edge of the canvas. This is a stylistic choice indicated by aesthetic considerations; I feel that so many parallel lines leading towards the canvas edge would be boring. Besides, Jay is anchored to life in his head and not by his feet. I spray the canvas with fixative and allow it to dry.

STAGE 2: FIRST UNDERPAINTING. The mixture for the head and hands is Prussian blue and white, in two shades. The hair is Prussian blue with a touch of raw umber and some white. I use the same mixture for the eyebrows and beard. I apply the pigment with the painting knife, blending it as soon as it is applied since alkyds dry rapidly. I then change to oil pastels, using a deep red for the tie and various shades of pink for the vest and pants. The shirt, too, is underpainted in pink. To these shades of pink and red I add burnt sienna when redrawing the figure and accenting some of the folds of the jacket. I also use burnt sienna to lend some warmth to the background that will eventually become cool. The charcoal lines remain part of the underpainting. I spray the canvas with retouch varnish and blend all areas, allowing some of the blue priming, the charcoal drawing, and the oil pastels to remain part of the underpainting.

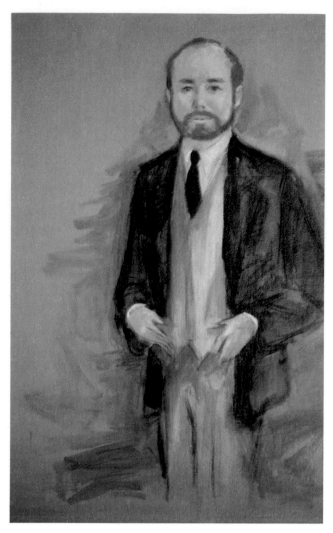

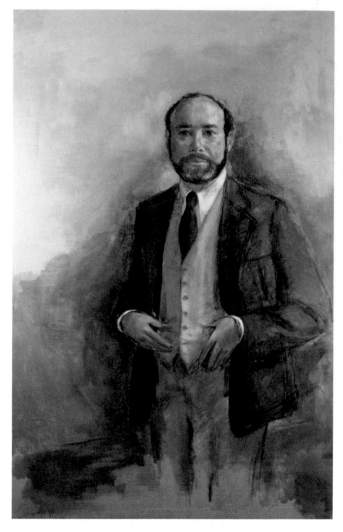

STAGE 3: SECOND UNDERPAINTING. I allow the canvas to dry for twenty-four hours before I begin the second underpainting. I mix three shades of Prussian blue and white and, using bristle brushes and turpentine medium, I refine the shadow areas, middle tones, and lights of the face and figure. The hair again is painted with Prussian blue and raw umber. The hands are refined in their hues, form, and gesture. Although I am refining the likeness, I am still preparing the canvas for the overpainting, and therefore I avoid details at this stage.

With a large sable brush I surround the figure with a Prussian blue glaze, using somewhat haphazard strokes. Jay is a restless person, and somehow such brush strokes seem indicated. I blend the head and hands with the blending knife and reestablish some of the drawing with the scriptliner and burnt sienna. I mix a glaze of Prussian blue and glaze lightly over the jacket. To this glaze I add some black and glaze over the tie. Using a large sable brush, I brush some light gray glazes over the shadow areas of the vest, pants, and shirt. To this glaze I add some white and subtly cover some of the pink underpainting, retaining the warm hue of the oil pastels. I start to indicate a background by brushing in a few strokes of raw sienna, in glaze form, on the bottom of the canvas. Then I put the canvas away to dry.

STAGE 4: OVERPAINTING WITH ALKYDS. I prepare the alkyds by mixing one part alkyd and one part ordinary flake white to make the paint more maneuverable. Alkyds are very intense in their tints; by their very nature, they produce a semi-opaque glaze. Applied with a sable brush and left alone, they leave just the right amount of pigment so that there is no need to scrape to produce the translucency of the underlying cool tone.

The shadow areas of the skin, both face and hands, consist of cerulean blue, a speck of cadmium red light, yellow ochre, and just a touch of white. The middle tones are cadmium red light, yellow ochre, and white, with some extra white added for the lightest areas. The eyes are raw umber, with a touch of raw sienna in the light areas. The hair is glazed with raw umber, with some ultramarine blue added for the darker areas. I paint the whites of the eyes with the lightest shade of skin tone. I use the mixture for the hair, for the eyelashes and eyebrows as well. To paint the lips I add a speck of burnt sienna to the middle skin tone; the line separating them is drawn with a scriptliner in burnt sienna. I spread a glaze of Prussian blue around the figure and across the lower part of the canvas. Into this glaze, and across the whole background, I paint several shades of gray, consisting of flake white, ultramarine blue, cadmium red, and raw umber; or I substitute cerulean blue for ultramarine blue. I apply the paint with a knife, scraping some of it and allowing other areas to remain undisturbed. I brush some of these grays onto the vest and trousers, thus binding the figure with the background. I glaze the jacket with Prussian blue, adding some black for the darker areas and folds. I add some white to the shirt collar and cuffs, then put the canvas away to dry.

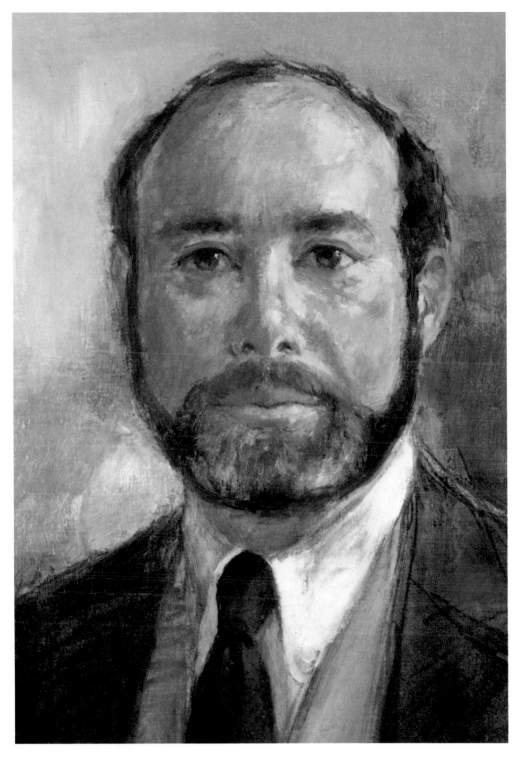

STAGE 5: FINISHING TOUCHES AND DETAIL.

When the canvas is completely dry, I spread a thin film of turpentine over it and allow the turpentine to evaporate. After that I spread a thin film of painting medium over the previous stratum and rub it into the surface with the palm of my hand. I then switch to regular oil paints. Somehow, perhaps because they are more pliant, they lend themselves much better than alkyds to subtle variations of color and touch. I retain one alkyd color, however: Naples yellow. It lends itself extremely well to the mixing of skin tones.

Using a sable brush, I lighten some areas of the face and hands with a mixture of flake white, cadmium red light, and Naples yellow mixed to a shade lighter than the lightest skin tones. I refine the drawing of the hands and add touches of burnt sienna

and gray to the beard. Where it's required, I paint some lights onto the shirt material, especially the slight slivers of the cuffs. Such color accents add interest to the painting and must not be missed. The tie is printed with red dots, which add just the right touch of whimsy, descriptive of the sitter. Although the original charcoal drawing remains visible, I redraw the figure with a round sable brush, using cobalt blue and a touch of black.

As you can see in the detail, traces of each layer are still visible on the final surface—the charcoal drawing, the oil pastels, the alkyd glazes and impastos and the finishing touches in oils. Of course, above all, I now have a likeness, a unique delineation of external and perhaps spiritual lines and shapes. Careful observation has helped to bring about this result, but full command of my tools and materials is important as well.

DEMONSTRATION 7
UNDERPAINTING WITH OIL PASTELS
OVERPAINTING WITH OILS

This is an example of using oil pastels in the early stages of an alla prima painting. The most important aspect of this painting is the gentle femininity of the subject, and the canvas has to be treated gently as well. Oil pastels are an ideal vehicle for this. The overpainting is done in the simplest possible manner. The gesture of the model, although soft, has its own strength. Both qualities must be reflected in the gentle but convincing application of paint.

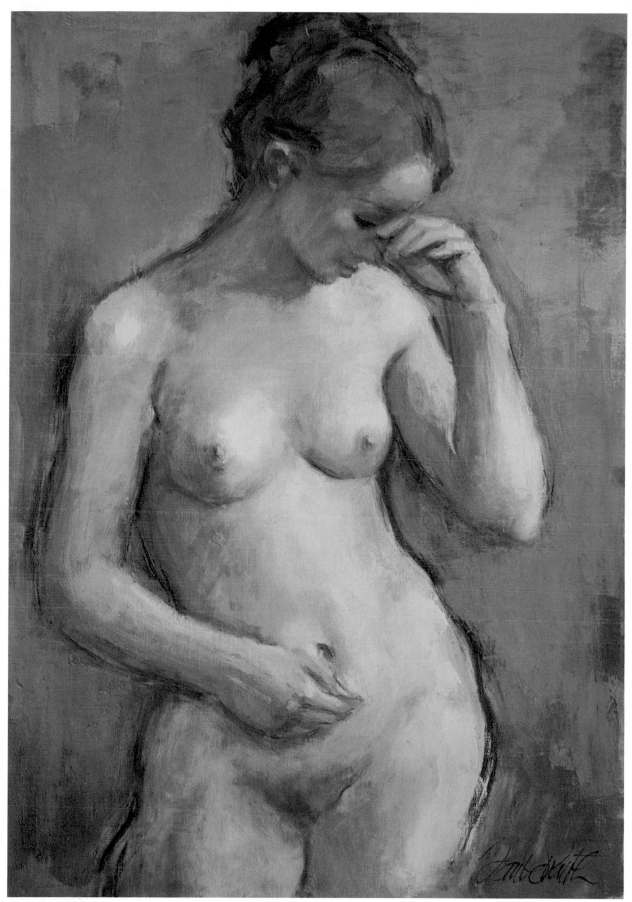

Reflection, 33″ × 23″ (84 × 58½ cm). Collection Dr. and Mrs.
James M. Hayes. Courtesy Alex Varga, Artists Representative,
New York City.

STAGE 1: THE DRAWING. I primed the canvas with a pink tone mixed from flake white, Venetian red, and raw umber, then allow then canvas to dry completely before beginning to draw. The advantage of having a variety of prepared canvases is obvious. Here, for example, if I had only a cool canvas available, I'm sure that I would never have achieved the warm translucency of this painting.

The drawing is done with charcoal. The diagonal swing of the hip and the motion of the head and hands produce its rhythm. There is neither detail nor correction in the drawing. At this stage it's important for the figure to be well placed within the canvas and for the anatomy to be in harmonious proportions; everything else will follow later. I spray the charcoal with fixative and allow it to dry.

STAGE 2: WARM UNDERPAINTING WITH OIL PASTELS. I use the pastels lightly. I avoid applying one on top of another so that I don't pick up or smear other hues. The figure is underpainted with two shades of pink to which I add white in the lighter areas. The hair is underpainted in two shades of the equivalent of yellow ochre and raw sienna. The pubic hair, too, consists of a yellow ochre underpainting. I redraw the figure with an oil pastel stick approximating burnt sienna in color. The background shades are light red in the upper part of the canvas and a darker red in the lower part. The priming is allowed to remain visible on a large area of the upper right corner. I spray the painting with retouch varnish and with the blending knife blend some areas of the background into an even mixture of warm hues, while allowing others to retain their original oil pastel quality. The knife must be wiped clean at all times. There is a certain ambiguity to this blending procedure. I move over the canvas lightly, but I'm not afraid to disturb some of the drawing, for it's this ambiguity that will intrigue the viewer. I allow the canvas to dry. This could take anywhere from five to fifteen minutes, depending on atmospheric conditions.

I continue painting when the canvas has reached the tacky stage—almost but not quite dry. All following applications are painted with medium. The mixture for the background is cerulean blue, some viridian green, a touch of Prussian blue, some raw umber, and flake white. I mix two shades, one lighter for the upper parts of the canvas, one slightly darker for the lower parts. I surround the figure, using a large sable brush in some areas and the painting knife in others. I scrape lightly over some parts of the background, leaving the warm underpainting visible.

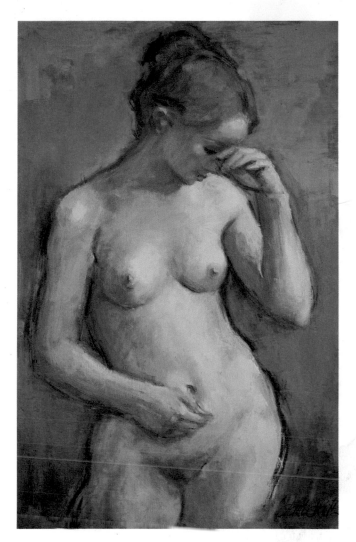

STAGE 3: FIRST OVERPAINTING. Over the shadow areas, I paint the impastos with bristle brushes, their size depending on the area to be covered. With the blending knife I scrape lightly over the light areas, lifting some of the paint so that the underpainting can play its part. I blend some of the light paint into the background and some of the background toward the figure. These blendings should meet at the edge of the figure, but if I miss a little, I can always correct it later when the canvas has dried. I blend some of the light skin tones with the shadow glazes. After adding a touch of raw umber, I glaze the dark parts of the hair. I reestablish the drawing with a scriptliner and burnt sienna, still avoiding detail, and add the eyes and eyebrows.

The mixture applied to the body is flake white and yellow ochre for the medium tones, with some white for the lighter areas. The glaze over the shadow areas consists of yellow ochre, ultramarine blue, and a little white, which achieves a light green. I apply the glaze with a medium-sized sable brush and allow it to dry.

At all times I use tools and pigments with conviction and strength, yet gently, as if I were caressing the canvas. I then allow the painting to dry completely for several days.

STAGE 4: SECOND OVERPAINTING AND FINISHING TOUCHES. I spread a thin film of turpentine over the whole canvas to wash off any excess fat remaining on the surface. When the turpentine has evaporated, I cover the canvas with a thin film of painting medium and rub it into the canvas with the palm of my hand. I then surround the figure with a Prussian blue glaze.

Now I step back from the canvas and decide what I'm going to do next. The painting doesn't need much more, and if I go one step too far, I'll lose the light and loose feeling. I mix a glaze of ultramarine blue, yellow ochre, and white, slightly darker than the skin shadow in the first paint stratum. With a sable brush I glaze the areas that need a darker shade: the cheekbone, around the eye, the inside of the left hand, underneath the chin, and on the right thigh. I mix yellow ochre and white to a shade lighter than the lightest shade of skin tones and apply the mixture with a bristle brush. I add some white and apply it into the freshly applied paint with the pointed painting knife. The mixture for the lips and nipples is Venetian red, some yellow ochre, and white, applied with a small flat sable brush. I blend these impastos with the knife, allowing for a complete dissolving of nipples into the surrounding area of light. I apply a light glaze of raw umber over some of the dark areas of the hair. With a touch of Naples yellow and white I lighten some areas of the hair, using a round bristle brush. I add some raw umber to the skin glazes and paint the eyes with a small round sable brush. With a small bristle brush, I add fingers to the hand. For the redrawing, I use a number 4 scriptliner and alizarin crimson; produces a livelier accent than burnt sienna. I blend some of these lines into the surrounding colors with a flat sable brush and leave others in sharp contrast. Then I allow the painting to dry.

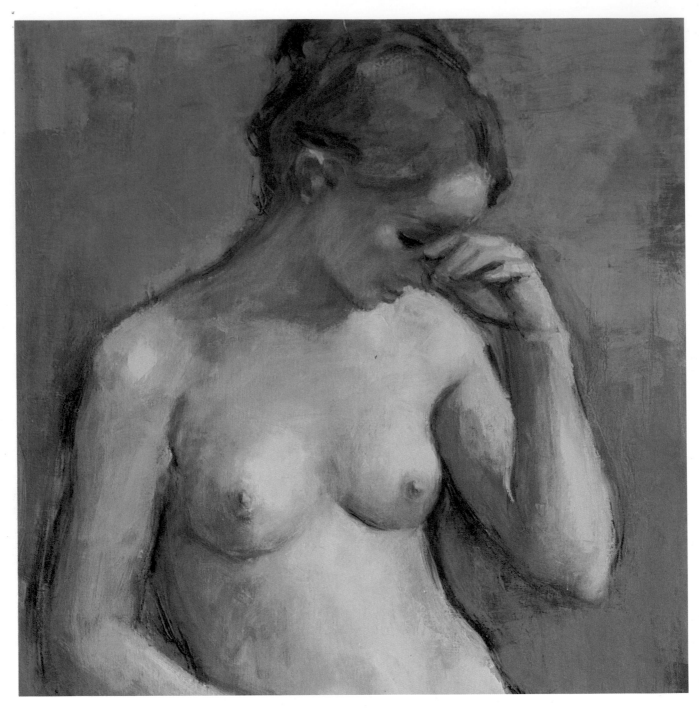

DETAIL. There are times when a painting seems finished, but something appears to be missing. When this is the case, it is best to put the painting away for a few days. You can always add that little something when your mind has cleared and you look at the painting with fresh eyes. Beware of impatience or painting without forethought. To paint too much is definitely worse than leaving a painting alone, even if it might be better with a touch here and there.

After a few days, I reexamined *Reflection*, and with one small addition I changed the painting. If you look carefully where the neckline leads to the shoulder, you'll see a light area in the background that creates a stronger contrast between it and the figure, adding more three-dimensional reality to the painting. It is a mixture of cerulean blue and white with a touch of raw umber, applied with a sable brush and smoothed with the palm of the hand. I also applied a touch of burnt sienna glaze to the shadow areas of each nipple with a small round sable brush. All layers are visible—the charcoal drawing, the oil pastels, the final paint stratum; even the soft pink of the priming adds warmth to the cool tone of the background. The alla prima method used here not only does justice to the materials and tools but also to the soft, gentle nature of the subject.

DEMONSTRATION 8

UNDERPAINTING WITH OIL PASTELS
OVERPAINTING WITH OILS
COOL UNDERPAINTING OF SKIN TONES
WARM OVERPAINTING OF SKIN TONES
WARM UNDERPAINTING OF GARMENTS WITH COOL OVERPAINTING

Be it a new material or a change in technique, experimentation adds to the joy of painting and supplies a new dimension in one's work. The somewhat garish hues of some oil pastels present the artist with the opportunity to venture into the unknown: What would happen if you began a painting with those colors?

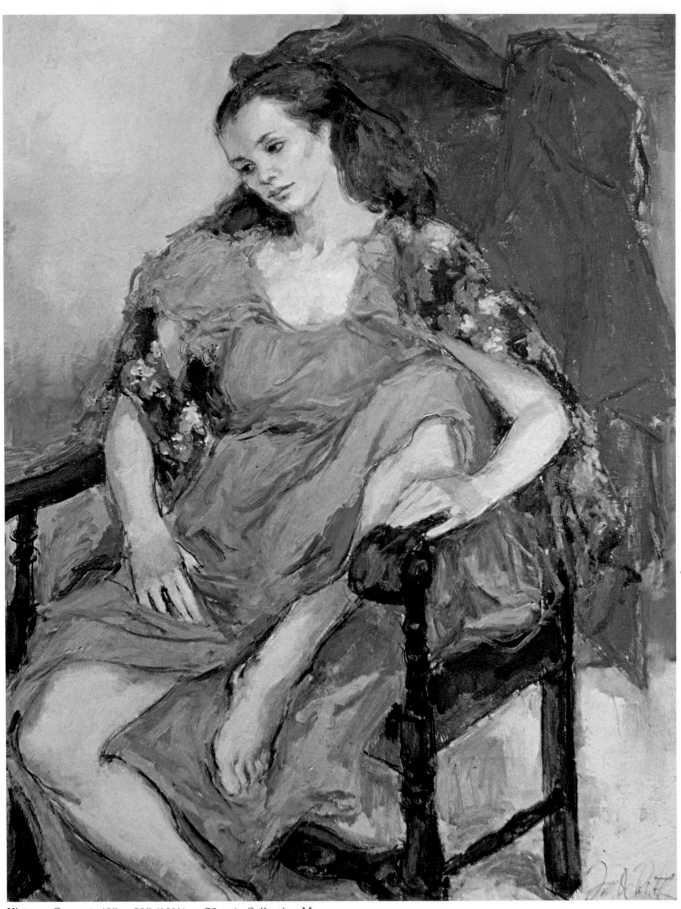

Virtuous Consent, 40″ × 30″ (101½ × 76 cm). Collection Mr.
and Mrs. David Kaufman. Courtesy Tyringham Gallery,
Tyringham, Mass.

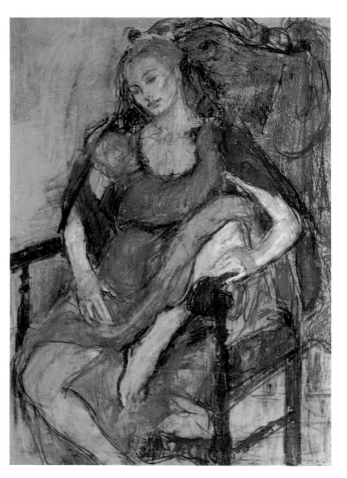

STAGE 1: THE DRAWING. Anticipating the "new" colors with which I will expand my color range, I also feel freer with my charcoal stick. The more a drawing departs from the reality of life, the better are the chances of creating the new reality of the painting. I avoid detail as much as possible, attempting only to capture the model's pose.

STAGE 2: UNDERPAINTING. I establish the skin tones with oil pastels in two shades of ochre, to which I have added touches of light blue and white. By their nature, oil pastels lend themselves to sketching and the artist should endeavor to keep as free a hand as possible when using them. When I say I apply the colors freely, I don't mean that I lose control. Each color must be applied with thought to fit the forms to be produced. The spontaneity of the charcoal drawing should be retained. Areas that will eventually be cool are underpainted with warm tones, and those that will ultimately be warm in cool tones.

I'm careful not to apply too many shades on top of one another; the pastels will pick up or smear a color underneath. I wipe the pastels each time they have touched another color so that their shade will remain pure.

I spray the canvas with retouch varnish, and with a blending knife I transform some of the pastel lines into a solid mass. In other areas I leave the pastels untouched, ensuring textural variety. During this process I also blend colors separated by tint or line so that they overlap a little; in the case of the hair, I allow the green of the chair and the blue of the hair to become one tone in some parts, leaving the original blue on top of the head untouched.

I then allowed the canvas to dry until it becomes slightly tacky. If I were to paint immediately over the wet oil pastels, I would destroy the surface. The great advantage of oil pastels, however, is that instead of having to wait a few days for the underpainting to dry, I can continue to paint almost immediately.

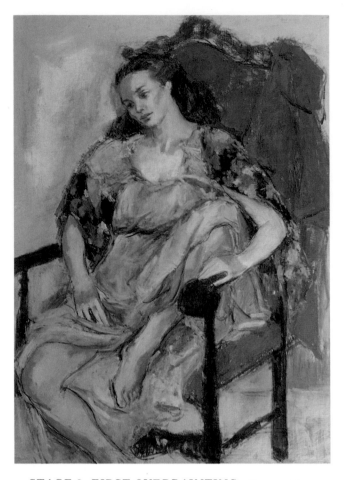

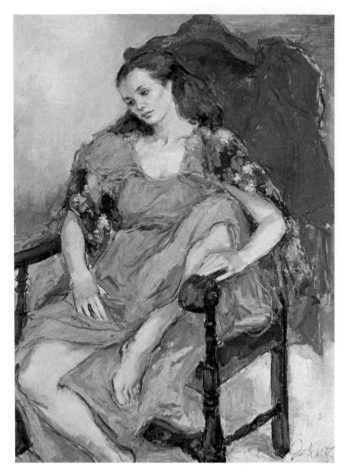

STAGE 3: FIRST OVERPAINTING. I use sable
brushes and painting medium to apply the next paint stratum.
For the shadow areas of the skin, I mix a glaze of flake white,
yellow ochre, and a touch each of cadmium red light and
ultramarine blue. For the middle skin tones I mix an impasto of
the same colors without the blue. I glaze the hair with burnt
umber, making the glaze a little more opaque in some areas and
leaving others untouched. The dress is a mixture of cerulean
blue, viridian green, and flake white, which I apply in broad
strokes with a large sable brush, allowing the underpainting to
show through. The frame of the chair is glazed with alizarin, the
upholstery with two shades of Mars violet and a touch of white.
For the cape that is draped over the chair, I add a touch of
cadmium red light and some alizarin, and I scrape away some of
the paint to allow the green and blue underpainting to show
through. The lower part of the chair is surrounded with a
viridian green glaze. I then mix three shades of gray and
scumble them with a round painting knife into the background,
leaving some of the yellow oil pastel untouched so that it
remains part of the surface. I paint all these colors into the print
of the shawl.

To reestablish the drawing around the skin areas, I use a
scriptliner and burnt sienna. To outline the dress and
background, I prepare a mixture of cobalt blue and
phthalocyanine green and apply it with a round sable brush. I
then leave the canvas for several days to dry completely.

*STAGE 4: SECOND OVERPAINTING AND
FINISHING TOUCHES.* After spreading a thin film of
turpentine over the whole canvas and allowing it to evaporate (it
washes off the oil residue from the previous stage), I apply a thin
film of painting medium.

The next step must be approached with caution, for it will
take very little to finish the painting. The composition, general
color scheme, forms, lines, lights, and darks have all been
established.

I add some lighter touches to the skin, using the same color
mixtures as before but with a little more white. These must be
thick impastos, or the skin tone will look chalky. I take some of
the color from the upholstery on the chair and paint it into the
hair, producing reflected color and variety. With a sable brush I
add some glazes of viridian green and Prussian blue to the
shadow areas of the dress, and then some lighter tones. Using a
round bristle brush, and gray mixed to various strengths with
cobalt blue, I lead the diagonal composition into the upper
right-hand corner and repeat the same shades in the lower
background areas. I paint the shades beneath the chair with a
round bristle brush, using viridian green mixed with white. I add
a few touches to the cape and fabric covering the chair. I draw
some of the carved detail on the chair's frame and add highlights
to the wood surface.

The background colors are still a little too strong for my taste,
in both color and application, so I correct this with some grayish
blues, keeping them in harmony with the rest of the painting.

My somewhat garish color scheme has paid off. I have finished
a painting in colors quite different from my normal palette,
which have led me to a whole series of paintings of a similar
nature.

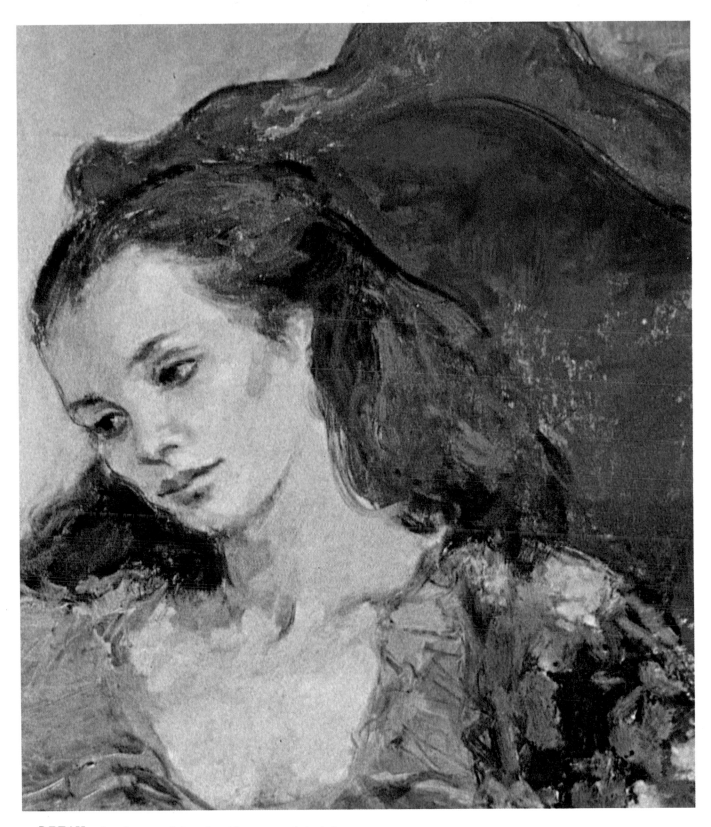

DETAIL. I took some of the colors that surround the hair and repeated them in the hair. Hair reflects light, and although highlights may appear to be white, to paint them white would introduce a "color" that is found nowhere else in the painting. In reality, hair may reflect the light shining through the studio window or skylight, but the skylight is not part of the painting. On the other hand, the hair would quite naturally reflect the colors in the chair. With white highlights, the hair would be lifeless, whereas with reflected colors, it harmonizes with the new reality of the canvas.

DEMONSTRATION 9
UNDERPAINTING WITH ALKYDS
OVERPAINTING WITH ORDINARY OILS

When I paint with standard oils, I usually work on several canvases at the same time to allow time for drying between paint applications that varies from several days to more than a week. There may be times, however, when you will want to speed up this process in order to complete a painting within a few days. That is when you will turn to alkyds. You can do the first underpainting, continue with the second underpainting the next day, and start overpainting with oils on the the third day. When time is of the essence, alkyds are a terrific addition to your paint supply. The alkyd palette does not include Prussian blue or Venetian red, but it is perfectly all right to use ordinary oils of these tints during the underpainting stages. The other alkyds suffice to dry the painting overnight.

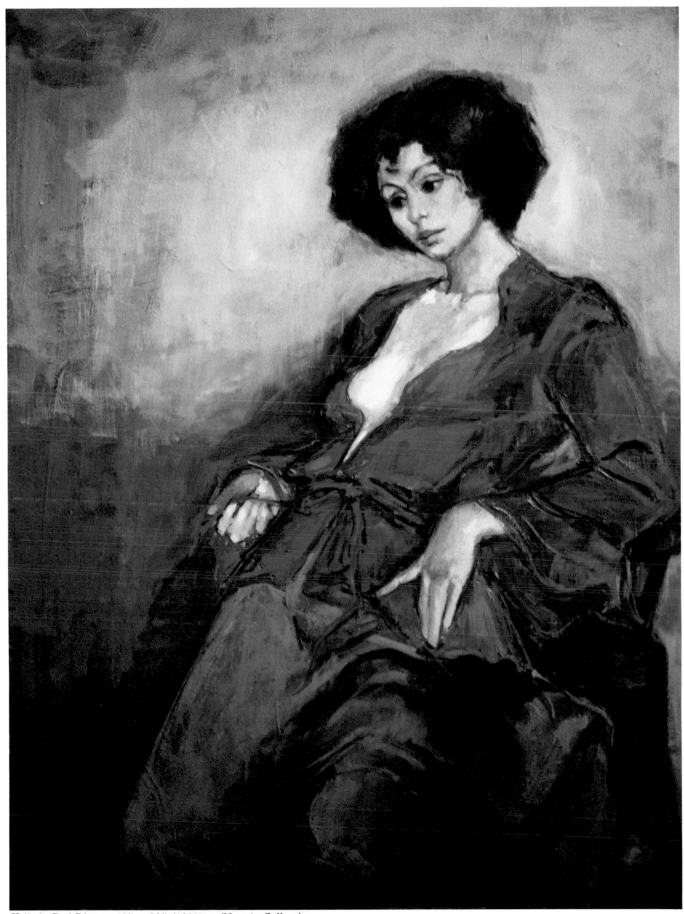

Kelly in Red Blouse, 40″ × 30″ (101½ × 76 cm). Collection
Mr. Larry Lindberg.

STAGE 1: THE DRAWING. For the drawing I use a round sable brush and raw umber mixed with turpentine. Kelly falls into dramatic and natural poses that have a certain flow, which the drawing captures as if she were between two gestures. Having established a rough sketch, I use a number 4 scriptliner to refine the drawing without paying much attention to detail. With a flat sable brush I add some darker areas to the hair and establish some of the folds of the skirt.

STAGE 2: FIRST UNDERPAINTING. I will be working with fast-drying paint, so I use a special palette. To keep the alkyds from drying too rapidly, I add one part ordinary oil paint to one part alkyd flake white. Although this mixture retards drying somewhat, I must still blend with the knife more often than when painting with oils; otherwise the paint will get too stiff to blend. For example, if I finish a part of the canvas, such as the head or the blouse, I must immediately blend it with surrounding areas rather than wait until I have finished all the underpainting.

The first underpainting is done with the small round painting knife and the blending knife. The mixture for the background is Venetian red and white, in two shades; the skin tone is Prussian blue and white; the blouse is yellow ochre, Prussian blue, and white; the skirt is Venetian red and some white; and the hair is Prussian blue with some white. I blend all these applications with one another. Then, using a scriptliner and burnt sienna mixed with turpentine, I reestablish the drawing. In this stage I have simply established line, shape, and color. I blend the whole canvas with a large sable brush and light horizontal strokes, cleaning the brush after every stroke. I then put the canvas away to dry overnight.

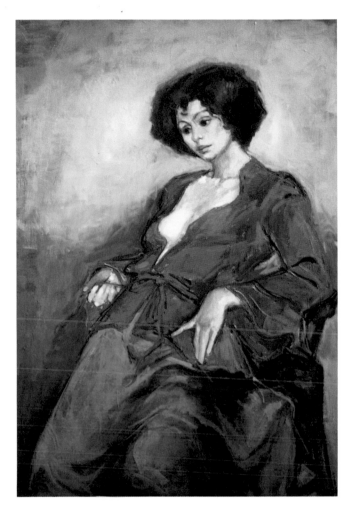

STAGE 3: SECOND UNDERPAINTING. I make sure the canvas is completely dry, then smooth any rough areas with fine sandpaper. The second underpainting is done with bristle brushes on the figure and with the knife on the background. For the background I mix three shades of Venetian red and white, still using the white mixture of one part oil and one part alkyd. The medium for this stratum is turpentine. The skin tones are three mixtures of Prussian blue and white, the lightest being almost white. The hair is a darker shade of Prussian blue and white than in the first underpainting, but I allow some of the former to remain visible. The blouse is yellow ochre, Prussian blue, and white mixed to three shades of green. The skirt is Venetian red, mixed with some white for the lighter areas and with some cadmium red for the shadows. The chair is painted in the same colors as the skirt and blouse. Again, I blend all areas with the surrounding pigments before the paint gets too stiff to move.

Using a scriptliner and burnt sienna, I once again reestablish the drawing, a little more precisely this time. Although I am now refining the form and shape of the whole figure, I still make no attempt to look for, and paint, detail. I blend the whole canvas with a sable brush, using long horizontal strokes. If the paint is too dry, no harm can be done so long as I have intermittently blended with the knife. I allow the canvas to dry overnight.

STAGE 4: OVERPAINTING IN OILS. Once again, I make sure that the canvas is smooth. If it's not, I smooth it with fine sandpaper. I spread a thin film of turpentine across the whole canvas and let it evaporate. Then I add a thin film of painting medium and rub it into the canvas with the palm of my hand.

I mix various shades of gray, using Prussian blue, raw umber, and cadmium red light or ultramarine blue, raw umber, and cadmium red light. I apply some of the paint with a large sable brush, some of it with bristle brushes, and some with the knife, then blend all areas. I mix a warm gray glaze from Venetian red, yellow ochre, ultramarine blue, and flake white and apply it to the shadow areas of the skin with a sable brush. For the middle and light skin areas I mix flake white, yellow ochre, and cadmium red light to three hues and apply them, blending lightly with the knife to allow the underpainting to play its part. I glaze the hair with a mixture of Prussian blue and raw umber, and I use the same color for the eyes, lashes, and eyebrows. I glaze the blouse with a thin film of viridian green and then, into this glaze, with a bristle brush, apply a mixture of cadmium red light with a touch of Venetian red, lightening it with Naples yellow (white turns red to pink and robs it of its intensity). I use a glaze of Prussian blue, in concentrated form, over the shadow areas of the skirt. With this glaze I mix cerulean blue and white and apply it to the rest of the skirt with a large sable brush.

I scrape some of the red from the blouse so that the green can play its part. With a round sable brush, I redraw the blouse and skirt with phthalo green and a touch of Prussian blue. Then I let the canvas dry for a day until it becomes tacky.

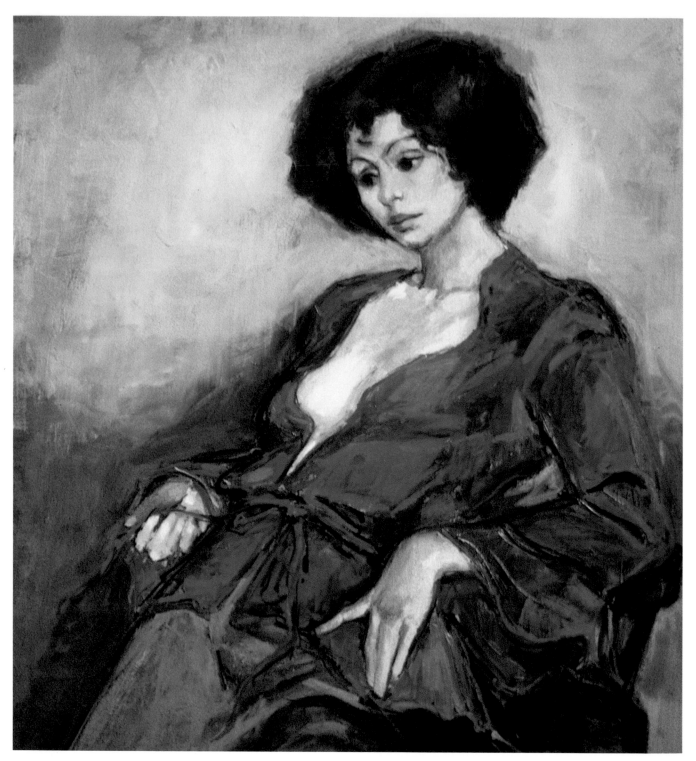

STAGE 5: FINISHING TOUCHES AND DETAIL.

Once you have attained a certain dexterity, you could finish a canvas such as this one in a day. But it is good to let the paint settle, then return to the painting with a fresh feeling. There may not be much that has to be done, but whatever you do has to be done with a rested eye and hand.

To *Kelly in Red Blouse* I will add some lights to the skin, cover the hair with a black glaze, and lighten the areas of the background that surround the head. You might brush a glaze of viridian green and Prussian blue over the chair and darken some of the lower parts of the background with the same glaze. You may wish to enhance some of the folds of the skirt. As to the detail, red is my favorite color—from orange to deep alizarin crimson. The best way to produce brilliant yet subtle reds is to underpaint in green, glaze with viridian green, then scumble various shades of red into the green. Be sure some of the green is visible; either do not paint on it, or scrape some of the red away. In some areas the green should be pure; in others the green will have a light haze of red. If you wish to enhance the red, wait until the painting is completely dry so that you can glaze it with a touch of alizarin crimson. If you add cadmium red light, with either the knife or bristle brushes, without disturbing the previous layer, you will produce a brilliant red.

The spontaneity of this painting is derived from Kelly's pose and the speed of paint application which the alkyds allow. If you can produce a painting within a short period of time, your chances of bringing about an explosion of feelings will be greatly increased.

DEMONSTRATION 10
UNDERPAINTING IN COOL TONES WITH ALKYDS
OVERPAINTING IN WARM TONES WITH ORDINARY OILS

The advantages of a fast-drying underpainting are manifold. You may wish to finish a painting in a short time for some practical reason. Also, a painting produced on successive days allows for dexterity and feelings to come forth in a more concentrated manner. Of course I would not suggest using only one method of painting, however advantageous it may be. Changing from one method to another will make your painting life livelier and more interesting, and it will also help improve your skills.

If you mix alkyd flake white and ordinary flake white as I have suggested elsewhere, you may need to experiment with the proportions, depending on the seasons and on atmospheric conditions in your studio. If you do not wish to mix oils with alkyds to supply the colors Prussian blue and Venetian red, substitute phthalo blue, with a touch of black to cut its intensity, and Winsor red, toned down with raw sienna.

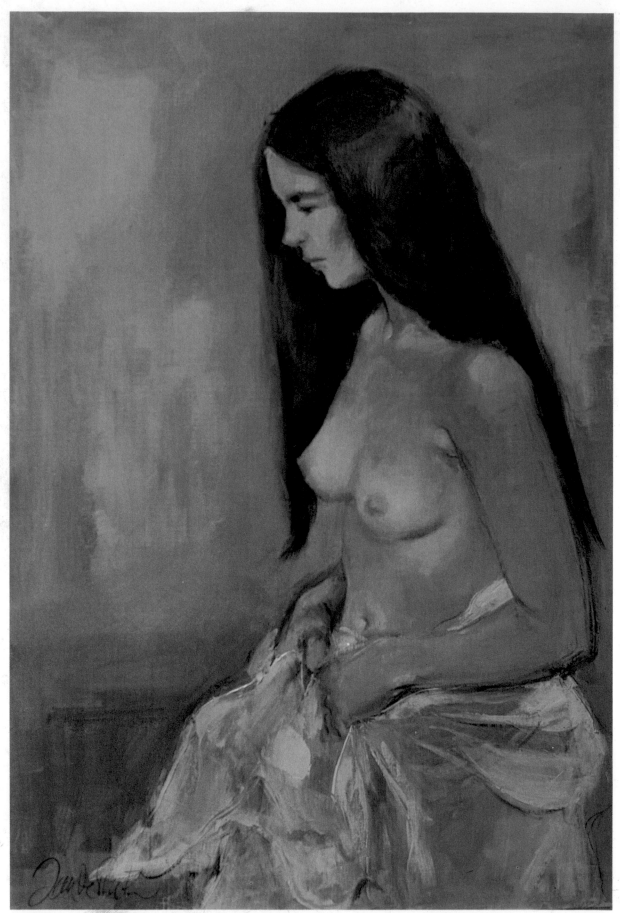

Awakening, 32″ × 22″ (81½ × 56 cm). Courtesy Karlebach
Gallery, Fairlawn, N.J.

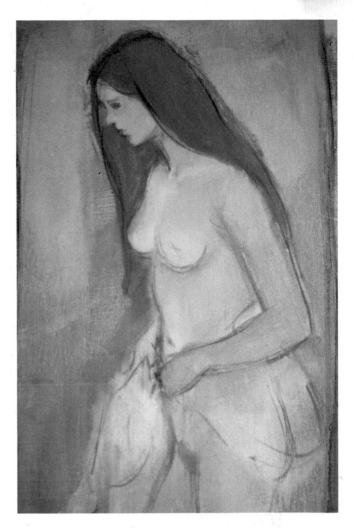

STAGE 1: THE DRAWING. I rough in the drawing with raw umber and turpentine, using a round sable brush to place the form and motion of the figure. I then refine the drawing with a number 3 scriptliner. By this I don't mean that I pay attention to details; what's most important at this point is to establish a beginning for the "new life" that will emerge on the canvas. The drawing will disappear underneath the paint, and I'll redraw after the first underpainting and again after the second one. I don't allow my feelings to be locked into a finished concept at the beginning, but let the painting develop a life of its own that is modified with each application of paint.

STAGE 2: FIRST UNDERPAINTING. Since I plan to work with alkyds, I use my special alkyd palette. Alkyds dry fast, and since I use the same method of underpainting as with oil, I must change the consistency of the white to make it longer (softer) and retard the drying process by mixing one part flake white with one part alkyd flake white and adding some turpentine.

For the first underpainting I mix three shades of pink by adding Venetian red (the Venetian red is an ordinary oil) to the white. Working with the small round painting knife, I surround the figure with the darkest pink; I use the middle tone for the light areas of the background and the shadow areas of the figure, the lightest tone for the light skin areas. I add some white to that mixture and use it to underpaint the drape. (It never hurts to paint a nude figure first to establish it, then underpaint the drape.) The hair consists of flake white, Prussian blue (from an ordinary oil set), and raw sienna.

When all the applications are completed, I blend them with the blending knife. Then I use a scriptliner and burnt sienna mixed with turpentine to reestablish the drawing. With horizontal strokes with a large sable brush, and moving lightly across the full canvas, I blend the figure, drawing, and background. I keep the brush clean at all times, so that I don't "drag" the paint and needlessly destroy too much of the drawing. Finally, I allow the canvas to dry overnight.

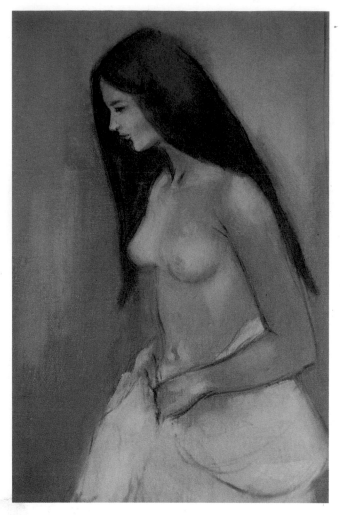

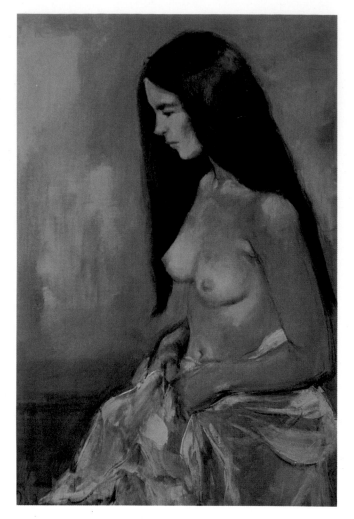

STAGE 3: SECOND UNDERPAINTING. After I've made sure that the canvas is completely dry, I erase any imperfections with fine sandpaper, then wash the canvas with turpentine and allow it to evaporate. I cover the canvas with a thin film of medium that has been well diluted with turpentine and rub it into the canvas with the palm of my hand. For the second underpainting I repeat the same mixtures of pink that I used in the second stage, but add one even lighter than the lightest of those. I apply the pigment to the figure with bristle brushes. With these brushes I can be more specific with form and tone, but I continue to avoid detail.

I apply the background with the round painting knife. The mixture for the drape is flake white and Naples yellow applied with the knife so that some of the first painting remains visible. The hair is Prussian blue and raw sienna with a little white added for the lighter areas. I use the blending knife and, with light strokes, blend within the figure, and the figure with the surrounding areas.

I redraw the figure with the scriptliner, using medium and burnt sienna. I don't trace the previous drawing; each time I draw becomes an opportunity for new discoveries. I use a large flat sable brush to blend lightly across the whole canvas, smoothing imperfections remaining from the knife and blending the drawing lines with the pigment. I allow the canvas to dry overnight.

STAGE 4: OVERPAINTING. I apply a thin film of turpentine over the whole canvas, allow it to evaporate, and then spread a thin film of medium over the canvas and rub it in with the palm of my hand. The final application of paint is made simple and easy by the warm underpainting. By keeping the mixtures that follow within a limited palette, I can produce a very engaging surface of color and texture.

I now change to oils and mix a glaze of Prussian blue, raw umber, and white to surround the figure. I prepare a green glaze by mixing yellow ochre, ultramarine blue, and white and apply it to the darker parts of the skin with a sable brush. Using a bristle brush, I apply a mixture of yellow ochre and white to the lighter skin areas, adding a little more white for the lightest parts. This mixture is opaque. Using the blending knife, I scrape lightly over this application to blend glaze and impasto. I lift off some of the paint so that the warm underpainting comes to the surface. A touch of Venetian red added to the skin tones is the nipple color, which I blend with the surrounding area. I use the same shade for the lips. I glaze the hair with Prussian blue and raw umber; the same mixture is the color of the eyes and eyebrows. I mix a speck of Prussian blue into yellow ochre and glaze the shadows of the drape. I add a dab of Naples yellow to white and scumble it into the lighter areas of the drape with the pointed painting knife.

To reestablish some of the figure's drawing lines, I use a scriptliner and burnt sienna. I use a round sable brush and white to delineate some of the shapes of the drape. (I do the same with the glaze that was used to glaze the hair at the bottom of the folds.) All this is done lightly. I add white to this glaze, mixing it to a light gray, and apply it to some parts of the background. With the blending knife I lift some of the paint to bring the underpainting to the surface.

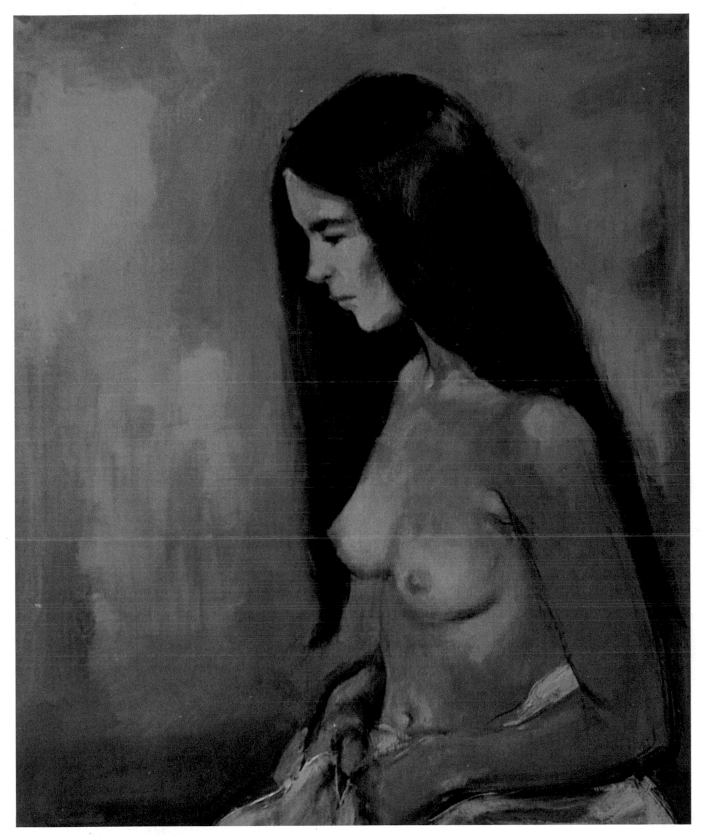

DETAIL. Using a limited palette, I have produced a painting that is rich in both texture and color. Combining the cool overpainting with the warm underpainting, and allowing both to appear on the final surface, draws all parts of the painting into one unit. Alkyds are valuable for more than practical reasons. These fast-drying paints can also serve as a catalyst to inspire you to produce a more spontaneous painting than you would achieve if it were completed over a period of a few weeks.

DEMONSTRATION 11

UNDERPAINTING IN COOL TONES WITH OIL PASTELS
OVERPAINTING IN WARM TONES WITH ALKYDS

The primary purpose of a portrait is to capture the likeness and character of the subject on canvas. A good portrait should stand as a work of art that attracts all who regard it, whether they know the person or not.

For this demonstration I selected one of my students, Christa Hagelman, to pose for a portrait in oil pastels and alkyds. Throughout the sitting I made certain that Christa and I maintained eye contact that would bind and isolate us from the rest of the world while the painting was in progress. If your sitter looks into your eyes, he or she will also look out from the canvas to engage the viewer.

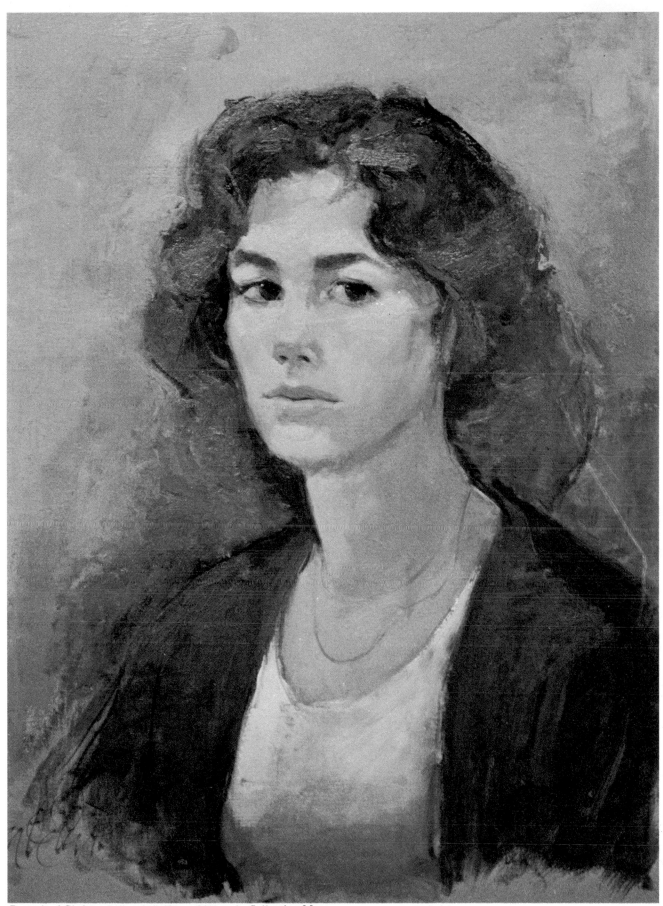

Portrait of Christa, 24" × 21" (61 × 30½ cm). Collection Mr. and Mrs. Rudy Hagelman. Courtesy Carrizo Lodge Gallery, Ruidoso, N. Mex.

STAGE 1: DRAWING AND UNDERPAINTING. In advance of the sitting I prepare the canvas, using a mixture of flake white, Prussian blue, and a touch of raw umber. I render a likeness with charcoal, with as few lines as possible, then spray it with fixative.

When the canvas is dry, I turn to my box of oil pastels and begin to sketch in the colors. I choose a middle shade of blue for the shadow areas of the face and a lighter shade of blue for the areas of light. Bear in mind that I already have a light blue underpainting, so the pastels are used in certain areas only; the underpainting provides the middle tones in others. I use a white stick to add lights. For the lips I use pink and yellow ochre; I add some white to keep the paint hues harmonious. I underpaint the hair in various shades of green with here and there some cobalt or Prussian blue. The eyes and eyebrows are a mixture of raw umber and ultramarine blue. I surround the head with various shades of red to pink, allowing the primed canvas to remain for the hair. Why red? Christa is a person of warmth, and one way to show character is by color. The background will be cool, but underpainting in red assures a warm reflection. The sweater is underpainted with viridian green. The upper part of the T-shirt is Naples yellow, the shadows yellow ochre.

I spray the painting with retouch varnish and immediately blend some areas with a blending knife. This is done lightly so as not to disturb the oil pastels. I scrape and blend areas of the background, covering some of the underpainting completely. I do the same to the sweater to achieve an even tone of green, but allow the sketch to show. I permit the retouch varnish to dry, for no longer than ten to fifteen minutes.

STAGE 2: When working with alkyds, *spontaneity* is probably the key word. Only small quantities should be squeezed onto the palette, as they dry very rapidly and at least half the paint would be wasted if normal amounts were used.

I mix a glaze of cadmium red, yellow ochre, ultramarine blue, and a touch of white and, working loosely with a flat sable brush, glaze over all the shadow areas of the skin. Still working with flat sable brushes, I mix yellow ochre, cadmium red, and white into two shades by mixing one tone and then adding a little more white for the lighter shade. I apply these mixtures to the light and lighter areas of the painting. This paint is neither a scumble nor a glaze in thickness, but somewhere between the two.

I then scrape cautiously with a blending knife. This has to be done with a light hand, for scraping too hard would disturb the oil pastel underpainting and destroy the spontaneous effect. I mix raw umber with painting medium to glaze the eyes, eyelashes, and eyebrows; with a light touch of my finger, I blend them into the surrounding areas.

I then mix three shades of gray from dark to light, by first mixing a dark shade and adding white for the additional shades. With the painting knife I apply these mixtures to the area surrounding the head, being sure to allow some of the red underpainting to show through clearly.

I glaze the dark parts of the hair with raw umber, using a sable brush. I mix raw sienna and yellow ochre and apply the mixture lightly with a sable brush. With the blending knife I blend some of the background into the hair in order to soften the contour.

116

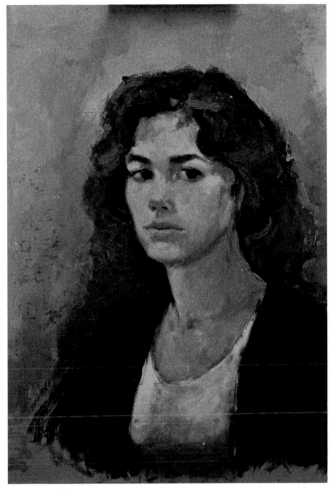

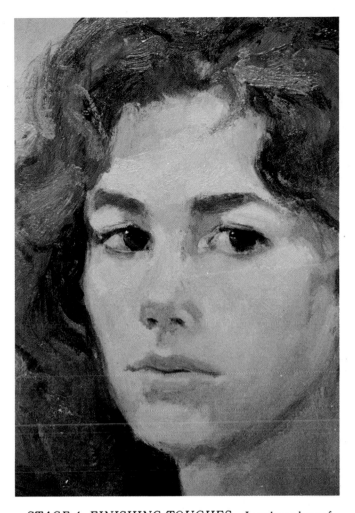

STAGE 3: At this point the alkyds are starting to dry, which is their great advantage. With normal oils I would have to put the painting away for several days so that it could dry.

Now, using round sable and bristle brushes, I become more specific with my likeness. I add a touch of darker glaze over shadow areas of the skin where it is needed; paint lighter areas with a heavier scumble, and add highlights. It is important to keep a light hand at all times, for although the alkyds dry fast, a heavy hand might destroy the tacky part of the surface.

I mix a glaze of burnt sienna and yellow ochre for the upper lip, add some white for the lower one, and blend both into the surrounding areas with a soft sable brush, separating them with a soft line of burnt sienna drawn with a number 3 scriptliner.

With a flat sable brush I glaze the sweater with viridian green. I then mix a soft red by combining some Venetian red from my other oils with the alkyd Winsor red and a touch of Naples yellow and apply it to the lighter areas with a flat bristle brush. With a round bristle brush, using cerulean and cobalt blues and some Venetian red, I add some strokes around the sweater to create depth.

STAGE 4: FINISHING TOUCHES. I apply a glaze of raw sienna and white over the dark part of the shirt, then scrape some of it to allow the blue underpainting to show through. With a bristle brush and knife, I paint the upper part of the T-shirt again and scrape some of it, to bring about a texture similar to the fabric of the T-shirt.

With a large flat sable brush, I wash over some of the underpainting and add a little cerulean blue to the grays, thus softening the overall effect of the background. I mix a little Naples yellow into the hair, and with a few strokes with a round sable brush I add some heavy impastos, giving the hair form and body. With the lightest shade of skin tone, I add highlights to the eyes, and with the number 3 scriptliner and burnt sienna I added some soft lines to the eyelids, shaping the neck with a heavier sable brush. With a mixture of burnt sienna and burnt umber I add some dark accents to the hair. Finally—and I am always torn as to whether to add jewelry—I add a necklace, having decided that it's in character with Christa's gentle being. I use a scriptliner and raw sienna for the dark areas and Naples yellow with white for the lighter ones, with a bare touch of a highlight so that the chain will blend into the painting and not draw attention to itself, as jewelry is apt to do. I add a few touches to the light skin areas, barely touching the canvas with the pointed painting knife.

I've finished the painting in about two and one-half hours. Such spontaneity is possible only with alkyds.

117

DEMONSTRATION 12
UNDERPAINTING IN OIL PASTELS (WARM)
OVERPAINTING IN ALKYDS (COOL)

There are two ways to use oil pastels as under-painting. You can apply the oil pastels and spray the canvas with fixative, leaving the various lines intact, and then let it dry. Or you can spray the pastels, then blend and scrape the canvas to produce a smooth surface very like that achieved with oils. The difference is that oil pastels make a thin application and oils, a heavy one. In this demonstration I blended the figure and left the background almost completely intact, although there is a little blending to produce a more homogeneous surface. I over-painted with alkyds because of their intensity and their fast-drying quality, which forced me to work efficiently. The color intensity of alkyds produces a maximum result with a minimum of pigment application.

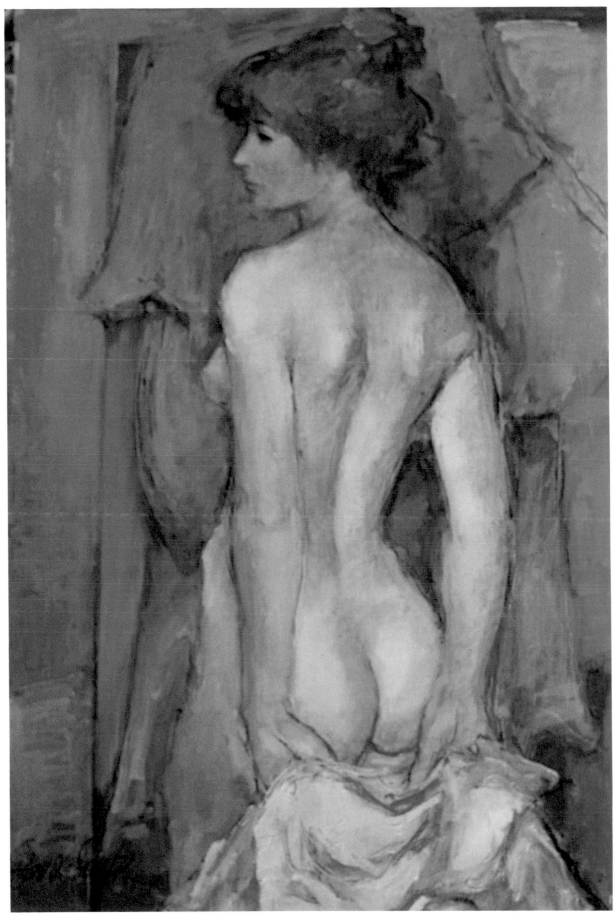

After the Bath, 30″ × 20″ (76 × 51 cm). Collection Mr. and
Mrs. Earl Burns. Courtesy Florence Art Gallery, Dallas, Tex.

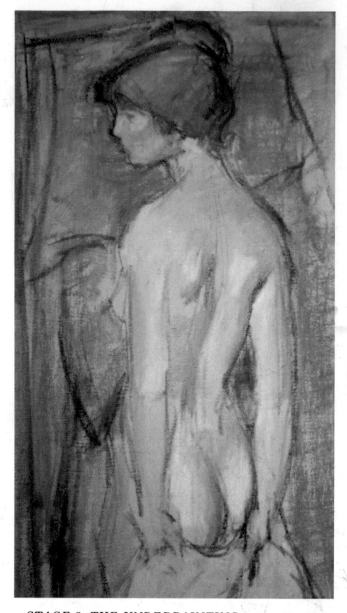

STAGE 1: THE DRAWING. The drawing, as in any alla prima painting, remains part of the final surface. That does not mean that it has to be a perfect "final result." On the contrary, the drawing is only one of the stages, though a very important one.

I sketch the figure with charcoal, making no attempt to define the face. The gesture of the figure is simple; when transferred to the canvas it will take on its own movement, held together with lines as if the figure were in subtle motion.

STAGE 2: THE UNDERPAINTING. Most oil pastel sets have two shades of pink. I use the darker one in the shadow areas and the lighter one for the middle tones and light areas. I add white to the light areas, making sure to clean the white stick so that it doesn't pick up pigment from the canvas. The hair consists of two shades in the yellow ochre family. I apply the background in various shades of cadmium red light to orange with some yellow ochre added. I suggest the drape with some light yellow with a touch of white. The few lines of light blue used to define the drawing are instinctive rather than based on a more routine procedure that would "prescribe" burnt sienna. The charcoal drawing is left to show through in most places.

I spray the canvas with retouch varnish and then blend the figure to achieve an even hue of pinks. I blend the background in some places and leave the oil pastels untouched in others. This begins to produce different textures that will be important in the final paint stratum. I allow the canvas to dry to a tacky stage (about five to ten minutes) before starting the first overpainting with cool alkyds.

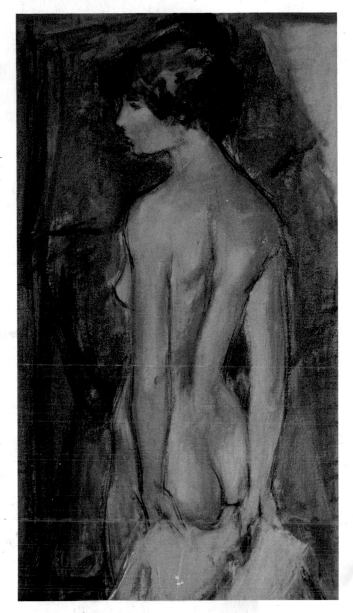

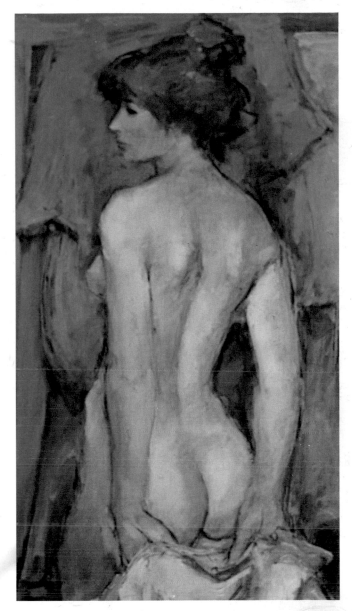

STAGE 3: OVERPAINTING WITH ALKYDS. I use alkyd flake white in its pure form, since I want the paint to dry as fast as possible. I continue by preparing a glaze of cerulean blue, yellow ochre, and white and spread it across the shadow areas of the skin. I add some Prussian blue to that glaze and brush it lightly with a sable brush across the drapes of the background, making sure that the warm underpainting remains part of the background. The hair is glazed in the shadow areas with raw umber. There are two mixtures of flake white and yellow ochre that I apply with a bristle brush to the middle and light skin areas. Note the intensity of the alkyd hues; it's important to be cautious with the amount of color added to white.

The robe is flake white and yellow ochre brushed lightly with a sable brush over the underpainting. The drape that appears as a warm hue is glazed with flake white and alizarin crimson, with some of the underpainting left to appear on the surface. I redraw some of the forms with cobalt blue, using a round sable brush. Using the painting knife and white mixed with Naples yellow, I add some pigment to the drape. Wherever the figure needs additional definition, I redraw it with a scriptliner and burnt sienna. With the blending knife I scrape and blend some of the figure and background. I allow the painting to dry until the surface is tacky before continuing. This could be anywhere from half an hour to one and a half hours, depending upon the atmospheric conditions.

STAGE 4: FINISHING TOUCHES. I mix alkyd white with an oil flake white—two parts oil flake white to one part alkyd white. The next layer is yellow ochre and white, applied with bristle brushes, to tone down some of the very cool skin tones. I add more white to this mixture to bring more light to the skin, blending and scraping constantly with the knife so that some of the pink underpainting will add warmth to the cool skin tones. The screen separating the blue background from the drapes is painted in phthalo green, with a touch of cobalt blue and white. I apply paint to the drapery with knife and brush, using different mixtures of ultramarine, cerulean, or cobalt blue. The robe held by the hand is glazed in the shadow areas with raw sienna into which I scumble white with a touch of Naples yellow.

With a round bristle brush and a mixture of Mars yellow, cerulean blue, and white, I add some light areas to the hair. A mixture of white, Naples yellow, and a speck of alizarin crimson, scumbled with a round bristle brush, produces areas of light on the rose-colored draperies. With a scriptliner and cobalt blue mixed with some viridian green, I redraw the figure and add form to the drapes, changing them to complement the figure.

When the painting is dry, I make some final adjustments. I add light touches to the face, shoulders, and buttocks. I glaze behind the head with Prussian blue, creating a three-dimensional quality that is always desirable when figure and background are to become one, when neither takes on a "leading role," but together form a unit that will appeal to the viewer's senses.

121

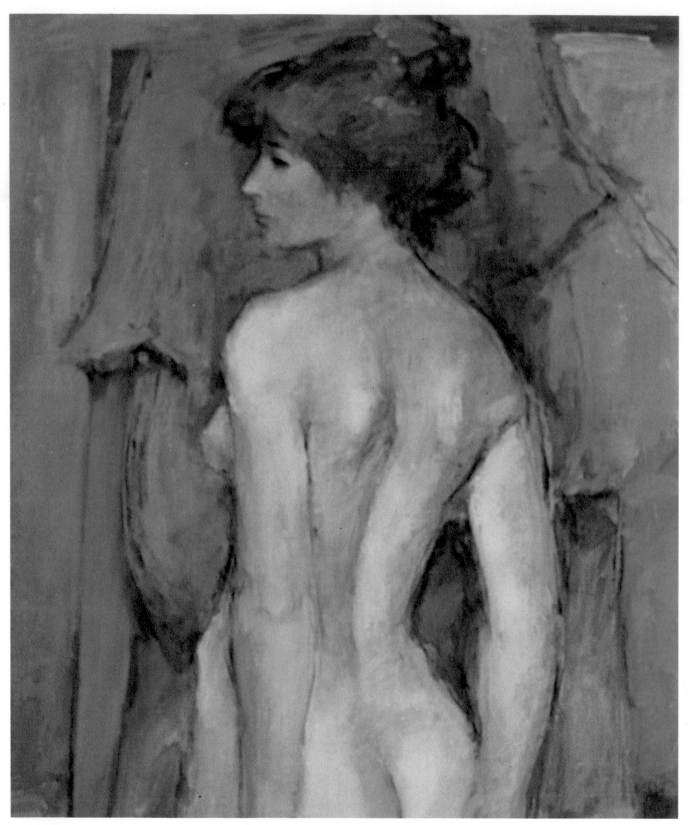

DETAIL. Neither the background colors nor the skin tones of this painting can really be found in life. Skin isn't green, blues are generally not of an electric nature, and if we were faced with either we would probably be taken aback, perhaps shocked, or even appalled. Yet in a painting we can arouse feelings in the viewer because of just such a juxtaposition of color and form. In a painting we're allowed to adjust and change—in short, to take charge of the miracles that paint, brushes, knives, and the spirit can produce.

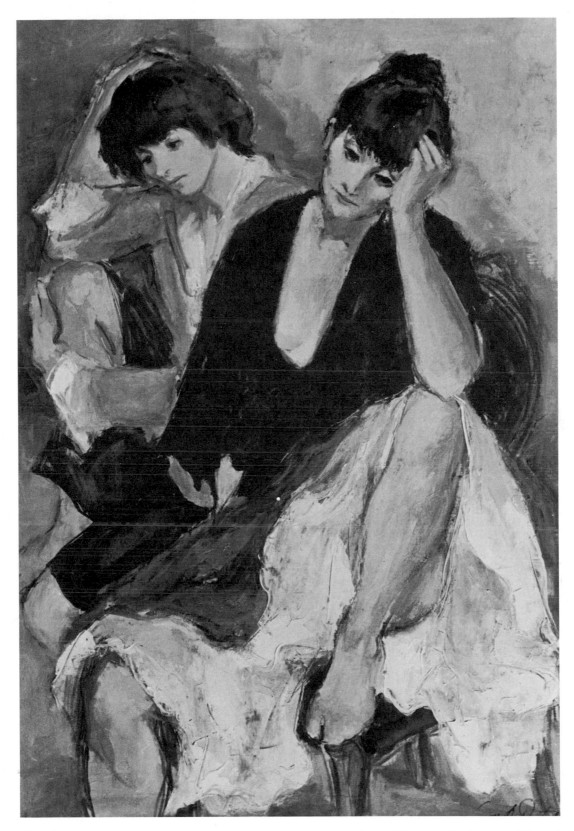

INTERMEZZO, 36″ × 24″ (91½ × 61 cm). Collection Mr. and Mrs. Warren H. Colonder. Courtesy Soufer Gallery, New York City.

This is a typical example of an alla prima painting. Much of the charcoal drawing is still visible in the finished work; you can see it in the outline of the wood parts of the chair and along the knee and calf of the frontal figure. The heavy impasto of the slip flows freely in contrast to the line of the drawing. In this painting it is the color more than anything else that unites the composition.

For example, the blouse on the foreground figure is black, as is the skirt on the figure in back; they form one area of color where they meet. The light red of the blouse on the figure in back is repeated more strongly in the skirt of the figure in front. The white of the slip is carried out in the lace on the figure in the rear. The black was first underpainted with a light red. I made no attempt to achieve solid blacks; on the contrary, through the translucent black we can see the glow of red, giving warmth and life to an otherwise dull color.

Part Four:
Painting Tips

As we come to the final section of this book, I'd like to remind you once more that you shouldn't get caught up in details during the early stages of a painting. Nevertheless, a painting is made up of details, be it an eye, a hand, or the fold of a garment, and eventually they must be painted—but in a manner that will harmonize with the rest of the painting.

The paintings on the following pages illustrate some of the techniques I use to paint details. I'm sure that there are many other ways to produce good results, but I believe that the simpler the approach, the more satisfying the results will be. Each part of the anatomy requires the use of certain tools, and each of these tools can produce a variety of results.

There are some rules, and you'll be well advised to adhere to them. Yet once you have made such rules part of your technique, the time will come when you should experiment and find your own forms of expression.

On these pages you'll find technical hints and methods that will make your painting life easier and perhaps add to the aesthetic quality of your painting.

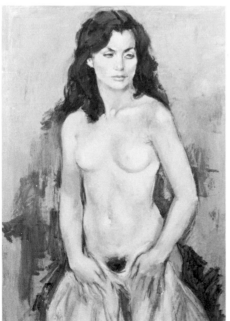

NOSES. NUDE DANCER, 36″ × 24″ (91 × 61 cm).

It's important to make a distinction between painting the nose of a figure in a painting and painting the nose of the subject of a commissioned portrait. In a painting, minimize the nose, and blend the shadow areas, medium tones, and lights well. Don't let the nose become the focal point of the face; allow it to be part of the face unit. The nostrils should be painted lightly, using burnt sienna and a scriptliner with soft strokes and a minimum of emphasis.

In a portrait, you must portray what you see and what is expected to be part of the likeness. Establish such shapes carefully within the monochrome of the underpainting. It's during the underpainting and with the monochrome that one can best establish a likeness. Above all, don't paint a white dot at the end of the nose as a highlight. There is a light area at some point of the nose, depending on its shape; but let it be like other light areas of the skin tones.

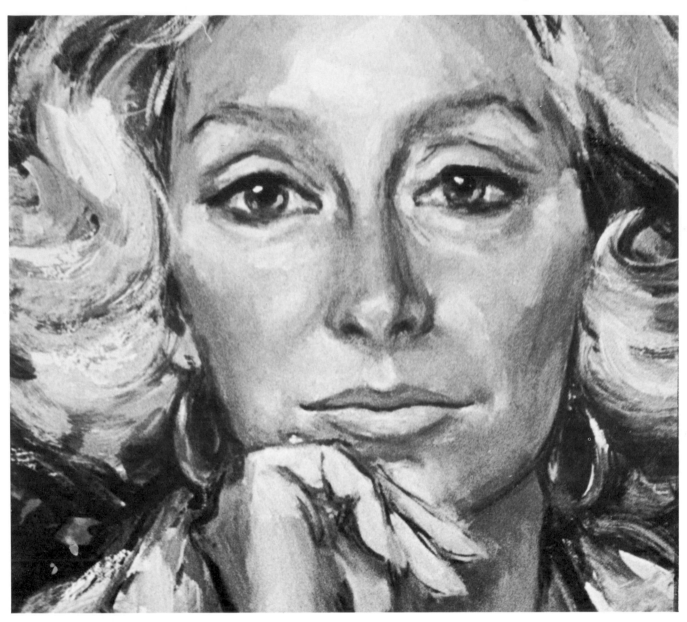

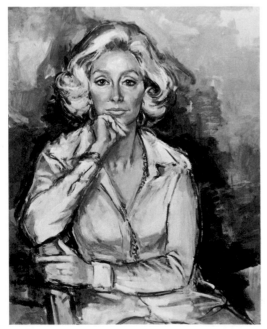

EYES IN PORTRAITS. MRS. STEVE LOHR, THE ARTIST'S SISTER, 40″ × 30″ (102 × 76 cm). Collection Mr. and Mrs. Steve Lohr. Courtesy Portraits, Inc., New York City.

It's when painting the eyes in a portrait that you can act on the belief that the eyes are the mirror of the soul. There are many ways to depict the character and spirit of a sitter, but none is more poignant than through the eyes. You must guard against letting the eyes become too obtrusive, even in a portrait, but you must also make sure that they are full of life. Find and paint the reflected colors in the pupils. Be aware that the eyelid creates a shadow over the upper part of the eyeball. Don't paint eyelashes individually, but with a horizontal line as you would see them from a distance of three to five feet. Blend all lines with their surrounding areas with a sable brush of the appropriate size. Don't get involved in detail in the early stages. Blend the eyebrows into the surrounding areas to make them part of the skin texture, so that they don't look as if they were drawn with an eyebrow pencil. Finally, the eyes in a portrait do require a highlight, but it must be in a subtle tone, perhaps one of the lighter shades of skin—*never white*. Always make sure the sitter looks into your eyes. Eyes painted in this manner will seem to look into the viewer's eyes and will even follow him as he moves around the portrait.

PAINTING EYES. REVERIE, 30″ × 20″
(76 × 51 cm). Courtesy La Monde Art Gallery, Dayton, Ohio.

Are the eyes "the windows to the soul"? Well, if they aren't, they certainly most often communicate as much, if not more, than the spoken word. In a painting that isn't a portrait, however, play down your fascination with eyes.

Chances are that when painting a face, you'd prefer to start with the eyes and move on from there. Before you do that, be sure to paint the surrounding passages; eyes are soft and should be blended with their surroundings. What we call the "white" of the eye should be of the same hue as a light skin tone, and the iris must be blended with it. There should be a minimum of color variety in the iris; otherwise it will attract too much attention. The best brushes to use are flat and round sable brushes. Above all, don't add a "white" highlight to the iris. If you need a highlight, use a subtle tone in the medium range of skin tones. Blend eyebrows into surrounding skin areas as well.

One more suggestion: when you're painting a nude, make sure the model's eyes are averted. People have difficulty looking into the eyes of a nude. For a portrait, the opposite is true.

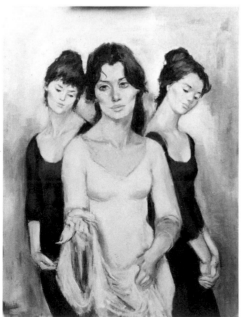

PAINTING THE MOUTH. FIRST REHEARSAL,
40″ × 30″ (102 × 76 cm). Collection Mr. and Mrs. Frederic Altman.

Lips are skin, and if you look carefully, you'll see that they adopt precisely the same color as some of the surrounding skin areas. Your light usually comes from above, which means that the upper lip is slightly shadowed; it should therefore be painted in a darker hue than the lower lip. Divide the lips with a simple line drawn with the scriptliner. The shape of this line varies from sitter to sitter and is most important. It, too, must be of a hue that's within the range of skin color; diluted burnt sienna is the best.

When painting lips wearing lipstick, don't be tempted to use fashionable colors. For a portrait, make sure the sitter wears a subtle color. If you're working with a model, she shouldn't wear any lipstick at all. Blend the lips into the surrounding areas with a soft sable brush.

Don't attempt to paint big smiles, whether in a painting or a portrait. Open mouths are almost impossible to paint without turning the painting into an illustration. As painters, we wish to convey an emotional kaleidoscope. We should never paint one specific emotion.

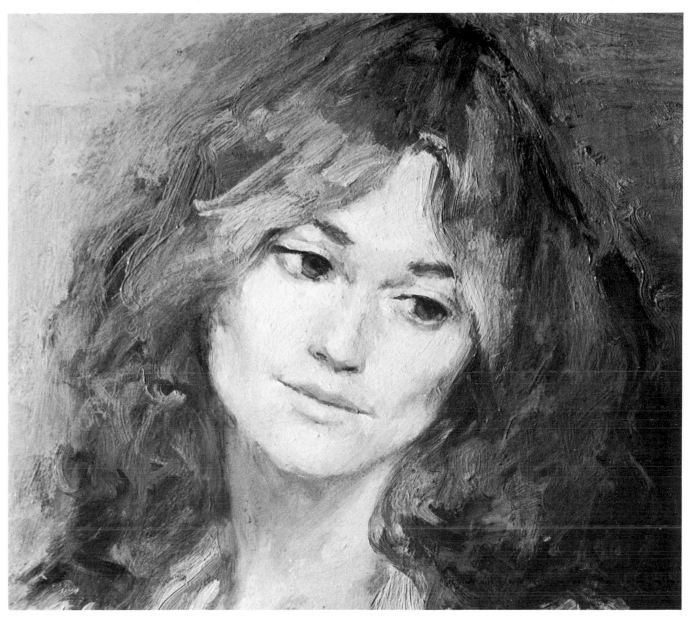

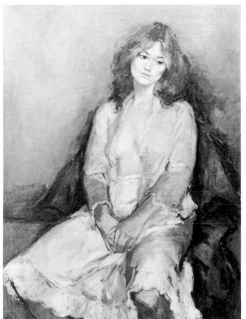

HAIR. FAR AWAY AND LONG AGO, 40″ × 30″
(102 × 76 cm). Collection Mrs. and Mrs. Jay Oberst.

It is an eternal temptation to paint hair with brush strokes that produce the illusion of hair with the impressions of the bristles. Hair painted with such precision will most likely look like a wig. Think instead of painting a landscape when you paint hair. Produce its lights and darks with a variety of colors, rather than with light and dark shades of one color. Use different brushes to glaze the darker parts. Be sure to blend areas of the skin with the hair in order to give the hair softness. Blend some areas with the background as well. Give shape to the head by redrawing some of its form. Use round bristle brushes to produce heavier brush strokes. Scrape some of these to allow the underpainting to show through. Vary color and texture as much as possible. Don't get too involved in detail. Hair is the head's crown—as such, make sure it's an integral part of the painting.

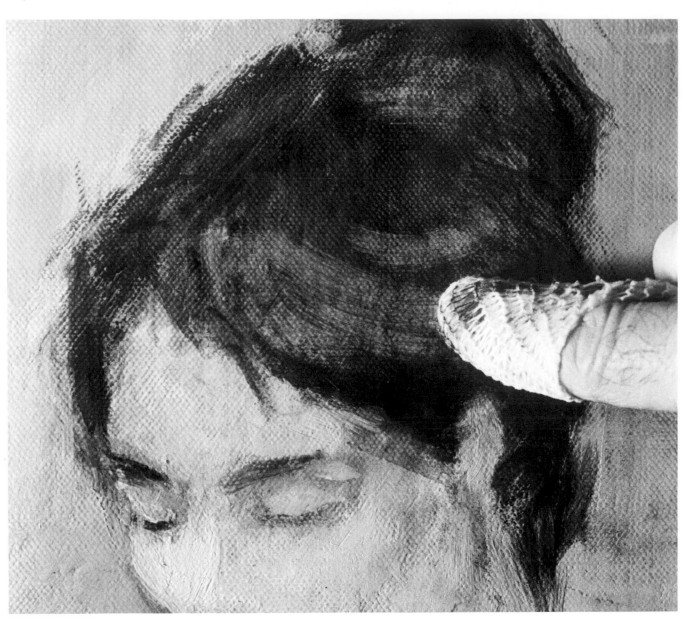

PAINTING HAIR WITH CHEESECLOTH.
FLOATING TEXTURES, 33″ × 23″ (84 × 58 cm).
Courtesy Gallery 306, Philadelphia, Pa.

Floating Textures was painted with a minimum of paint. I used an alla prima method, with oil pastels as the underpainting. I kept the overpainting light and airy in context with the pose and the mood of the day. The technique for painting hair that I described previously would attract too much attention in a painting such as this. Instead, I used a method that's both subtle and very persuasive.

The hair was underpainted in blue tones; I then glazed it with raw umber of a heavy consistency. I allowed enough time to pass for the turpentine in the medium to evaporate and solidify the glaze. I then wrapped a piece of cheesecloth around my index finger and, with light strokes, wiped off some of the glaze. While the cheesecloth picks up the glaze, it also leaves an impression that resembles the texture of hair. You must change the cheesecloth after every stroke. Two or three strokes will suffice. You can't correct mistakes; if you make one, you must wipe the glaze off completely and reapply it. As with any technique, don't overuse this procedure.

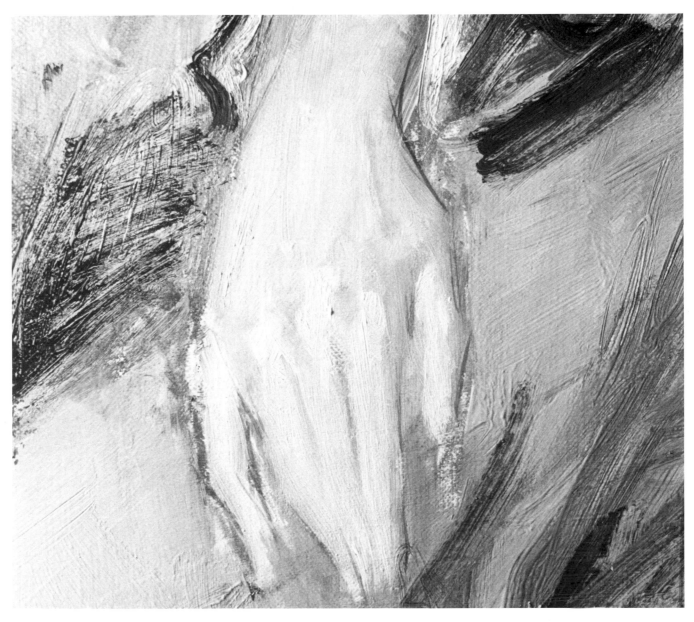

PAINTING HANDS. GREEN SKIRT, 24″ × 18″
(61 × 46 cm). Courtesy Provincetown Art Gallery, New York City.

Hands are the most difficult part of the human body to paint. Positive thinking is the most helpful suggestion I can make. Instead of being awed by this complex anatomical miracle, just say to yourself, "I can do it." Believing you can is the first step.

Like any other part of the body, the hand is made of line, dark and light. Don't try to reproduce it, but rather try to paint its function of the moment. Imagine the hand you're painting to be a glove, and imagine slipping your own hand into it. Close your eyes and feel its motion, feel every finger, and re-create what you see with your own hand, finger by finger. All at once, you'll discover its flow.

Make sure that you underpaint the hand correctly, so that all you have to do later is glaze, overpaint, add lights, and redraw some of the linear aspects. Blend the hand with some of its surrounding areas. This will anchor it to the rest of the painting. One more hint: paint the hand as if it were between motions, and paint it lightly. If you don't succeed the first time, scrape off the overpainting and repaint it rather than belabor a bad start, even if you have to do this several times on the same hand. Suddenly, everything will fall into place and you'll find yourself painting hands with ease.

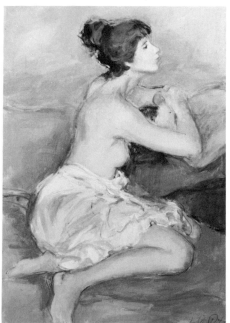

PAINTING FEET. SUNDAY, 33″ × 23″
(84 × 58 cm).

The feet, and especially the toes, are rather complicated anatomical machinery. Since by virtue of their function they end up somewhere near the edge of the canvas, make sure not to paint them with too much emphasis or detail, which would attract the viewer's attention to the edge of the painting and perhaps away from the focus of the canvas—the last thing you want. I think feet aren't the most attractive part of the human anatomy; the solution—simplify! Paint them with a minimum of detail. Paint them softly, yet keep in mind that they must ground a standing figure to the floor. Allow surrounding areas to give them their form. Use a scriptliner to redraw them. Paint their motion rather than their detailed structure. When I say eliminate some detail, I don't mean to become sloppy. Be sure that the foot's form fulfills its function, but soften its awkwardness with the "painter's reality."

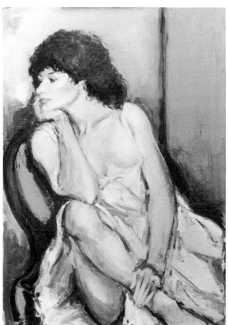

GLAZING. HERSELF IN HER EYE, 36″ × 24″
(91 × 61 cm). Courtesy Riggs Gallery, San Diego, Calif.

Glazes probably contribute more to a painting than any other painting stratum. They enhance any stage of pigment application. While the underpainting establishes the base, the glaze adds a richness that opaque painting cannot produce.

On the forearm of *Herself in Her Eye*, the underpainting was done in shades of light green. The shadow area was glazed with Venetian red, yellow ochre, a touch of ultramarine, and a speck of white, producing a pinkish-gray tone. The glaze was applied with a sable brush and left alone. The cool tones of the green underpainting, combined with the warm glaze, produce an ideal skin tone. Should you attempt to achieve such a hue by mixing cool and warm tones on the palette, all you would get is a gray, maybe not instantly, but in time.

Glazes lend themselves to the shadow areas on garments. If you surround a figure with a glaze and scumble various shades of pigment into it, allowing parts of all three strata to be visible, you'll create a rich yet harmonious surface.

The following colors are suitable for glazing: burnt sienna, raw and burnt umber, raw sienna, alizarin crimson, viridian green, phthalocyanine green, Prussian blue, and black. Glazes add depth and richness to a canvas, but use them sparingly, for too many glazed areas are monotonous.

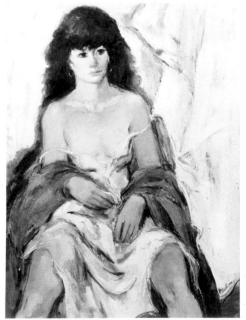

HEAVY IMPASTOS. CIRCUS GIRL, 34″ × 24″
(86 × 61 cm).

An impasto is a heavy application of paint. You may produce it with a bristle brush; however, the most effective impastos are those applied with a knife. In *Circus Girl* the heavy impastos balance the strong gesture of the pose. I used both the round painting knife and the pointed painting knife to produce the variety of impastos. Those applied to the background are scraped and blended here and there to allow some of the underpainting to show through. You'll produce the most effective impastos by first glazing over the underpainting and then applying the impastos with vigorous strokes. It's important to think ahead; don't just apply paint and hope that it will take on the shape you expect. Remember that different knives produce different results. Although the resulting surface may have the appearance of having been rather haphazardly applied, you can achieve such an effect only with practice. If you apply the paint with too much caution, the painting will lack the spontaneity that applications of heavy impastos require. It's better to scrape off unsuccessful attempts until you achieve the forms you desire. Above all, resist the temptation to cover the whole canvas with such impastos. There's nothing more boring than a canvas painted with knives only.

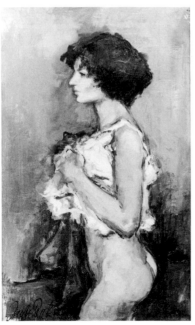

UNDERPAINTING, GLAZING, AND IMPASTOS.
PROFILE OF LOVE, 20″ × 12″ (51 × 30 cm).

The painting's final surface must allow every application of paint to play its part. For example, the underpainting in this canvas is visible slightly through the glaze applied over the belly and the shading of the left half of the figure's bottom. Impastos applied with brush enter into the lighter areas. A heavy impasto applied with the knife and then blended with the blending knife into the surrounding areas appears on the waist muscle, into the hip bone toward the thigh. By changing tone and variety of texture, I created the illusion of a three-dimensional form on a one-dimensional surface. Of course, you could create a similar effect with a straight chiaroscuro technique. The shapes would be there, but they would be dull because they would be of one texture, rather than produced by the translucency of underpainting, glaze, and impasto.

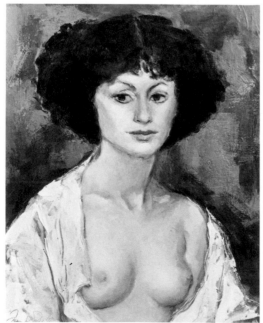

PAINTING BREASTS. COLUMBINE, 25″ × 19″ (64 × 48 cm).

Always keep in mind that all areas of a canvas should be treated with equal importance. When painting your model's breasts, most of the time you will have to adjust nature to fit the new reality of the painting. Don't paint breasts either too large or too small. Make sure the nipples are placed in the middle of the breasts. Don't paint them from above, or they will not look firm. Keep in mind that skin on the nipples is just that—skin. The nipples should blend with the surrounding skin tones and vary just slightly in color. Don't emphasize their importance through color or shape. The less time you spend on the nipples, the better will be your chances of success. Note how the softly blended breasts in *Columbine* contrast with the heavy impastos of the garment. Such is the desirable textural variety of a painting's surface.

THE BREAST IN PROFILE.

Rarely is a figure painted straight on. The moment the figure turns even slightly, the breast's shape begins to change. By the time a three-quarter view is reached, one breast appears in profile. There is but a short distance between the two breasts, yet the other one in profile seems slightly smaller and lower because of the perspective involved. Such changes, although minute, must be observed most carefully; anatomy must be true to life before you can alter it to fit the reality of your painting.

When you paint a breast in profile, be careful to underplay the nipple, even more than in a frontal view. If you paint a highly visible nipple you will distract the viewer from the general mood of the overall painting, weakening its seductiveness. Always blend the breast with parts of its surroundings; don't isolate it from the rest of the body. If there is a need to reestablish some of its shape after blending with knife and brush, use a scriptliner and burnt sienna diluted to a light tone to reestablish the shape with a line or two.

There are of course painting styles that are preoccupied with depicting the realities of life with all its perfections and imperfections, but I think painting should improve on life's imperfections.

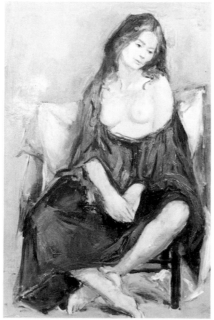

PAINTING WITH THE PALM OF THE HAND. AT REST, 36″ × 24″ (91 × 61 cm).

Charcoal, brushes, knives, cheesecloth, and other tools are actually extensions of your hand, but there are functions that can be performed by the hand alone with greater dexterity.

After having painted all kinds of textures on a canvas, you may wish to create areas of relief or unimportance. Of course, if such an area of unimportance is in the right place, it may become truly important. You may have painted your background, glazed and overpainted, the canvas grain may be visible—all these aspects are desirable. Yet, you may wish certain parts of the background to become distant, more subtle than the surrounding areas. To achieve this, use the palm of your hand. With a wiping motion, rub lightly with your palm over the areas that you want to recede. (Clean the palm between strokes.) The textures will disappear and "atmosphere" will take their place.

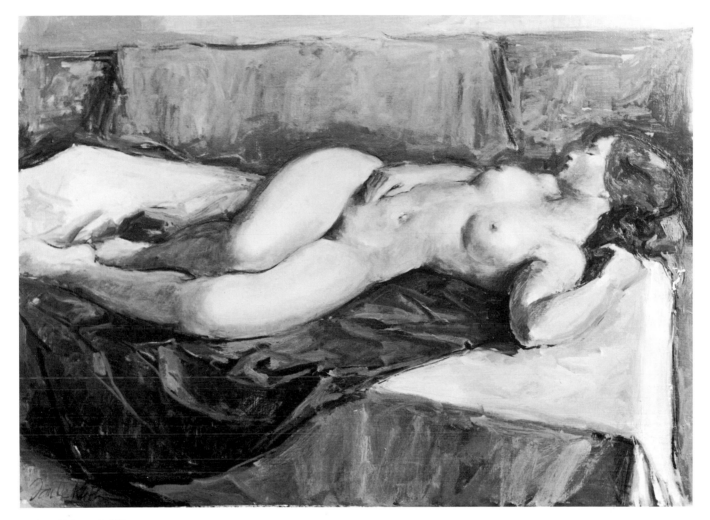

SUMMER DAY, 35″ × 45″ (89 × 114½ cm). Mr. and
Mrs. Joseph Brody. Courtesy Harbor Gallery, Cold Spring
Harbor, N.Y.

One is certain to achieve a successful composition by placing a
diagonal line through the rectangular canvas; the effect is subtle,
yet always dynamic. On this day I had shifted the bed so that it
was on a diagonal from my view, and the model leisurely
stretched across it, forming a line opposite that of the bed. The
drape runs parallel to the figure and offers a contrast to the
shape of the bed. The part of the drape that hangs over the side
of the bed is rounded, harmonizing with the model's right thigh.
Her left arm, bent at the elbow and extending to her hair,
balances the right thigh as well as the overhang of the drape.

The hand in profile seems to work well on reclining figures
but must be painted as simply as possible. A face turned away
from the viewer produces a feeling of peace and calm. I painted
this canvas almost completely in one day by the alla prima
method, adding only a few touches after the paint had dried.